EAMES

Design Monographs

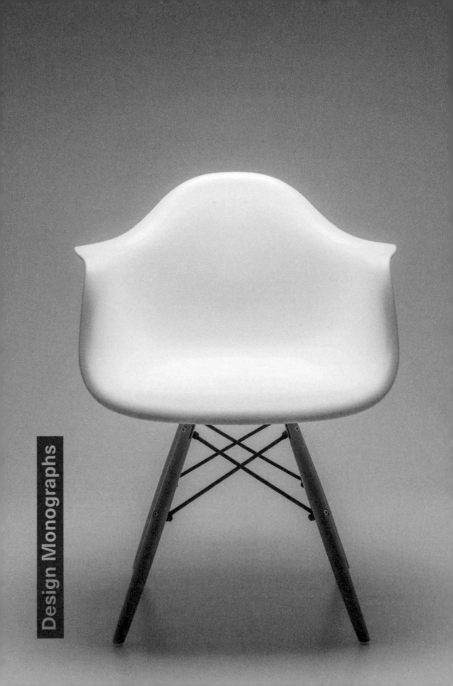

Design Monographs

EAMES

NAOMI STUNGO

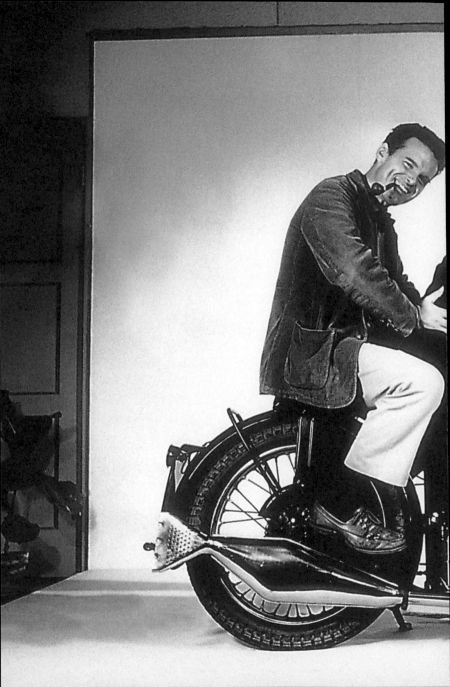

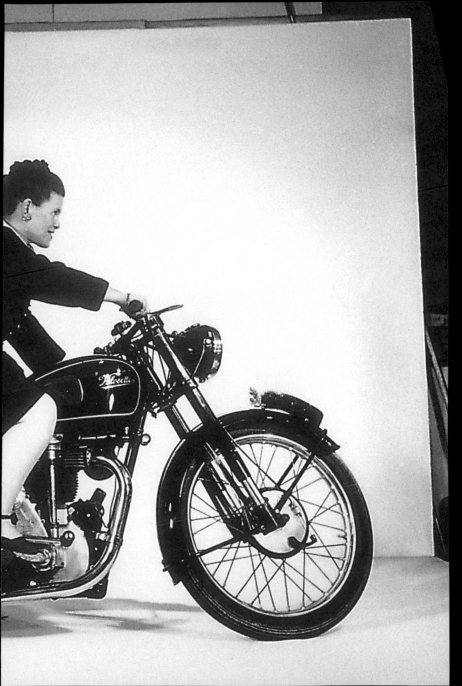

Charles and Ray Eames | Here is a curious thing: while designers such as Frank Lloyd Wright, Le Corbusier and Alvar Aalto have gone down in the history books as the "greats" of the twentieth century, you are far more likely to have come across the work of a lesser-known couple – Charles and Ray Eames.

In schools and offices, airport lounges and government buildings, museums and private homes around the world, you will find seating designed by the American husband-and-wife team, Charles and Ray Eames. Their work is so ubiquitous, so much part of our visual landscape, so much what we expect furniture to look like that it is almost impossible to imagine anyone actually hunched over a desk designing it.

The Eameses not only changed the way the world sits, they also revolutionized what it meant to be a designer. Charles Eames liked to describe design as "a method of action" – that is, a verb, rather than a noun: an approach to be applied to any problem. Besides furniture, the Eameses designed splints for the American army, buildings, films, exhibitions and multi-media presentations. If this multi-pronged approach is what we expect from designers today, it is because the Eameses pioneered it. As designer and editor Timor Kalman said, "Charles and Ray changed everything."

Given the Eameses' importance, it is surprising how little has been written about their lives. During his lifetime, Charles Eames deliberately discouraged what he called "memorial monographs". As Pat Kirkham (who later wrote such a book with the support of Ray Eames) explains, Charles preferred to look forward and not to rehash the past: being "written up", he felt, implied that one's life's work was done. Since Charles's death in 1978, details have gradually emerged about their lives. They are pretty sketchy in places, but it is possible to piece together a story about how the most important American designers of the twentieth century came to be.

Charles Eames was born in 1907 in St Louis, Missouri. As a small child he was introduced to the Froebel system (as Frank Lloyd Wright had been), a pioneering teaching method that encouraged kindergarten-aged children to

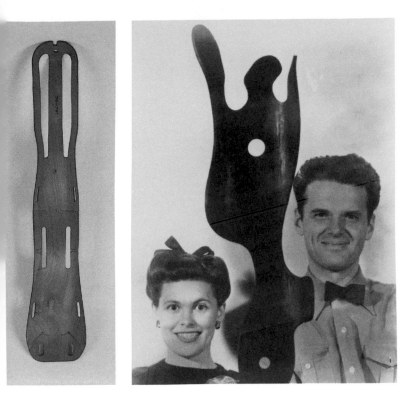

Above left. Leg splint for the US Army, 1942. **Above right.** Charles and Ray pictured with a plywood sculpture developed while experimenting with the material.

play with geometric wooden toys – spheres, cubes, pyramids and triangles – in order to stimulate their spatial awareness. Whether this played a part or not, Charles quickly developed a keen sense of form and design. At the age of 14, after his father's death, he took a part-time job at the Laclede Steel Company in Venice, Illinois, where he was soon promoted to the engineering shop as a draftsman. He was clearly talented. Not long afterwards, a rival firm, Aitkens Mills Company, offered him a scholarship to study engineering which he turned down – he had decided to become an architect. In fact, Charles never qualified as an architect. He was thrown out of Washington University three

years into his training. Despite his popularity – Charles's eminent good looks, charisma and talent were widely commented on at the time – his ideas were too radical for the old-fashioned, beaux-arts-style architecture school. Charles, who champed at the bit to explore the ideas of the "modern" architects coming out of both Europe and America at the time, was ejected in 1928 for "premature enthusiasm for Frank Lloyd Wright". His teacher, Gabriel Ferrand, went as far as telling Charles's prospective father-in-law that he would never amount to anything as an architect.

At first, things seemed to go well. The following year, he married Catherine Woermann, one of a few women training to be an architect in St Louis at the time. The couple honeymooned in Europe, visiting France, Germany and England, and seeing buildings by many of Europe's leading modern architects – Ludwig Mies van der Rohe, Le Corbusier, Walter Gropius. Charles later described the effect as electrifying jolt to his sensibilities, like "having a cold hose turned on you".

Back home in the USA, Charles set up in practice as an architect with Charles Gray. The timing could not have been worse: the country was plunging into the worst economic crisis of its history – in three years from 1929 to 1932 the American stock market lost 90 per cent of its value, industrial production slumped by a half and the building industry collapsed.

Looking back, Charles was philosophical. "Now going into [the] practice of architecture in 1930 is really something. And it's the greatest thing that could happen because you practise architecture and you have to do everything. And we did some little churches, we did some houses and residences and, if there was sculpture to do, you carved the sculpture. If there was a mural to paint, you painted the mural. We designed vestments, we designed lighting fixtures and residences, rugs, carvings ..." The Depression helped broaden his outlook, but it took its toll on Charles's health and he found himself plunged into a deep personal crisis.

In 1933, he paid off what debts he could, left his wife and young daughter behind and headed off to Mexico for what he later descried as an eight-month "on the road tour". Looking at the work that he was later to produce, it is easy to see that Mexico must have been another jolt to his system. With its rich tradition of inexpensive, hand-crafted and brightly painted goods, it was a

visual feast after Depression-era America. Charles sketched and travelled (and was twice arrested), soaking up the atmosphere – the sun, the colour and the sheer freedom of it all.

Although he never formally graduated, Charles always referred to himself as an "architect" rather than a "designer". Despite the outrage that he had provoked at architecture school, the houses that he designed on his return to the USA before meeting Ray were modern without being radical – a fashionable if eclectic hotchpotch of colonial revival, modern and Scandinavian styles.

The Scandinavian influence owed something to the work of Eliel Saarinen, the well-known Finnish architect (who emigrated to America in 1923 with his son Eero and the rest of his family) whose work Charles knew well. The respect was clearly mutual. In 1938, Eliel Saarinen invited Charles to come and teach at the Cranbrook Academy of Art in Detroit, the influential design school of which he was director. It was here that Charles was to meet Ray.

In a relationship as close-knit as Charles and Ray's, it is difficult to know where one half's contribution ended and the other's began. Of the two, Charles was by far the more ebullient, the more at ease in public, and as a result, it was generally he who spoke about their work. Although he always stressed the part Ray played, this tended to get overlooked and, when she died in 1988 – ten years to the day after Charles's passing – there was scant recognition of her contribution in most of the obituaries. In the decade that she survived her husband, she first completed the projects that remained outstanding, then sidelined design to give talks about their shared vision, and to write about it.

In fact, Ray Kaiser (as she was born) played a vital role in creating America's most dynamic post-war design team. Born in 1912 in Sacramento, California, Ray showed an early aptitude for art and design and, when the family moved to New York, she threw herself into the art scene, enrolling at the Art Students League. In many ways, Ray's tastes were far more avant-garde than Charles's. Besides studying under the German emigré artist Hans Hofmann, Ray took dance classes with the legendary American choreographer Martha Graham and was keen on film. She quickly developed into a successful artist in her own right and was a member of the American Abstract Artists group, which exhibited at some of Manhattan's most progressive galleries.

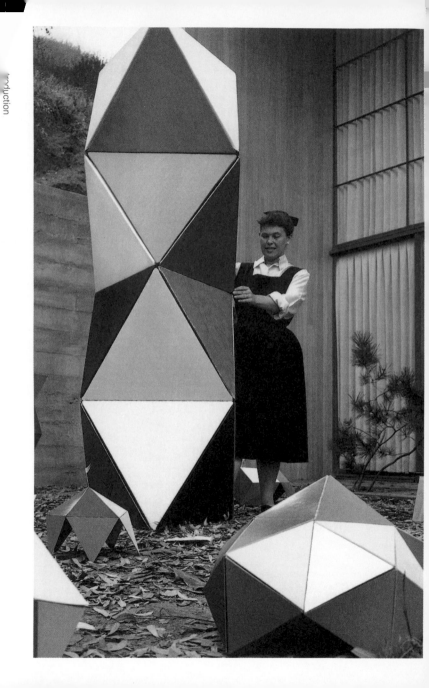

In 1940, after her mother died, Ray decided to move to California and build a house. She stopped off in Cranbrook for four months. As she later explained: "I hadn't had any practical training, and I thought that would be a very good thing to know – you know, to increase my knowledge of how things are done. At one time, just before finding Hofmann, I was going to study engineering ... somehow I've always been interested in structure, whatever form it was – interested in dance and music, and even my interest in literature had that base, I think ... as structure in architecture. This seemed the perfect place because [I had heard] about Eero Saarinen and [the] great potter, Maija Grotell."

At Cranbrook, Ray met Charles. Exactly what happened never seems to have been written about. The pair were obviously hugely attracted to one another and it is not hard to imagine why: Charles was dashing and magnetic; Ray as bright as a button. Professionally, too, they were ideally suited: Charles had experience of engineering and building; Ray of colour, structure and forms. By 1941, they had married, moved to California and set up their own design office.

The Fred and Ginger of the design world, it is impossible to think of Charles and Ray individually. They go together: like strawberries and cream, neither is as good on its own. In public Charles may have come over as the dominant force but theirs was an equal partnership. You only have to look at photographs of them to sense this. Very often they are wearing matching outfits and, almost always, they are holding hands or both touching the same object. They never had any children of their own (though Charles had a daughter from his first marriage); work was their focus and they threw themselves into it with equal fervour. In a makeshift studio in their rented Los Angeles apartment with a home-grown moulding machine made from scraps of wood and bicycle parts, Charles and Ray quickly began experimenting with plywood. Cheap and flexible, it seemed an ideal material for a new kind of design, one that was lightweight and modern, inexpensive yet beautiful.

Charles had started to use plywood at Cranbrook, where he and Eero Saarinen had jointly won first prize in the Museum of Modern Art's "Organic Design in Home Furnishings" competition in 1940, with a range of plywood tables and moulded plywood chairs. Together, he and Ray now began to

Opposite. The Eameses turned their hands to anything; nothing was out of bounds. Here, Ray experiments with an early prototype for The Toy.

...evelop these ideas, looking at how best to design moulded plywood seats – a tricky problem as plywood tends to shatter when bent into acute angles.

Using their home-made moulding machine, they succeeded in making a single-piece plywood seat (although it did not meet their criteria of being able to be mass-produced). The work was perilous, however, as a member of the Eames office later recalled: "They [Charles and Ray] had built this vast curing oven that required a lot more current than they could get from their house service. So supposedly, Charles climbed up the pole with a large piece of heavy insulated cable … so as to bypass the fuses to run this huge resistance oven they constructed. He has himself talked about doing this on occasion. He was scared to death."

Their first commercial work was not furniture, however, but designs to help the American war effort. The West Coast in the 1940s was the home of America's aircraft industry and a strategic naval centre. In 1942, the Eameses were commissioned to develop plywood leg splints for wounded soldiers and aircraft components. The job enabled them to rent a studio – 555 Rose Avenue in Venice, Los Angeles – and hire a whole team of staff. Financial pressures eventually forced them to sell out, but nevertheless, by the end of the war, they had produced 150,000 splints and learned how to mass-manufacture plywood pieces.

This new expertise was to lead to the creation of one of the most successful chairs of all time. Before that, Charles and Ray embarked on designing their own house. In 1945, the progressive Californian architecture magazine *Arts & Architecture* launched the Case Study House programme. The idea was to commission leading contemporary architects to design a series of prototype houses. The houses, which had to be relatively inexpensive, were to be illustrated in the magazine, opened as show houses and finally sold. The man behind the programme, the magazine's editor John Entenza, knew the Eameses well (Charles and Ray were editorial advisors and regular contributors) and he commissioned them, together with Eero Saarinen, to build one of the 26 houses.

Opposite above. The home-made plywood moulding machine in the Eameses' Los Angeles apartment, 1941. **Opposite below.** Ray Eames sitting on an experimental lounge chair, 1946.

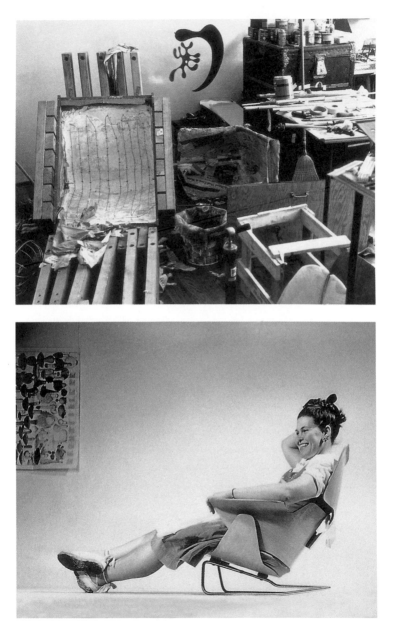

The house the Eameses built at Pacific Palisades is one of the most striking twentieth-century houses. As with all the Case Study houses, it was meant to show how industrial technology could revolutionize house-building, providing low-cost but desirable homes for all. The building's steel and glass structure was erected by five men in just 16 hours, the roof and deck completed in three days. This was no mere machine for living in, however; not just a technical solution to a construction problem. It was fun. Onto its steel skeleton the Eameses clipped a series of coloured panels – some opaque, others translucent – windows and sliding doors. Pat Kirkham has described the effect as "a Mondrian-style composition in a Los Angeles meadow".

The original design for the house was rather different from the one that got built. The original scheme – in which an all-glass-and-steel house was raised up on "pilotis" or stilts and looked out towards the ocean – was drastically revised, becoming a far more colourful, low-slung house that turned into the landscape rather than looking wistfully out to sea. The changes perfectly reflect the infusion of Californian warmth and colour the Eameses brought to modern architecture.

Some of the Case Study houses were sold to private buyers, but not all. The Eameses designed their house for themselves. And if the outside was a challenge to the norms of chilly European modernism, how much more so was the inside. The Eameses were inveterate collectors. Over the years, they built up an astonishingly eclectic collection of beautiful objects – everyday items, ethnic art, toys, as well as high art – which they displayed on every surface of the house, even the ceiling. As American architect Robert Venturi says, the Eameses "reintroduced good Victorian clutter. Modern architecture wanted everything neat and clean and they came along and spread eclectic assemblages over an interior – they created valid and vivid tension within our art – minimalist and now maximalist at the same time!"

The Eameses designed one other house, again with Eero Saarinen, this time for John Entenza. They also designed a showroom for Herman Miller, the furniture manufacturer. But then they stopped designing buildings. Charles later explained: "I guess I'm a cop-out. Designing a whole building is just too

Opposite. The Eames House. Designed as a prototype modern home, the house used fast-track construction: the frame was erected in just 16 hours.

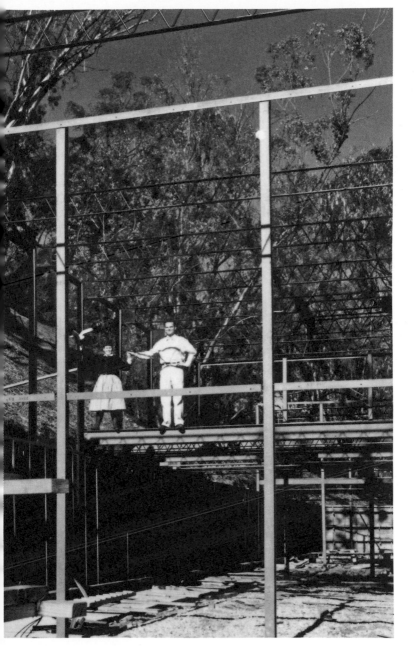

demanding of attention to keep the basic concept from disintegrating. Builders, prices, materials, so many things work towards lousing it up. I've chosen to do things which one can attack and control as an individual. Furniture design or film, for example, is a small piece of architecture that one man can handle."

For the decade or so after 1945, furniture became the prime focus of the Eameses' office. Charles had already begun to make a name for himself thanks to the 1940 MoMA exhibition, and in 1946 the museum gave him a solo show in which he displayed their latest experiments, including several beautifully simple single-piece plywood seats.

Hard as the couple had tried, it soon became clear, however, that single-shell plywood seats simply didn't work. No manufacturer was going to produce a chair that might break at any moment with potentially catastrophic consequences. So, with typical pragmatism, the Eameses set about looking for a solution. The design they came up with – the dining chair with metal legs and its cousin the lounge chair with metal legs – was a stunningly simple answer, a chair in which the seat and back were made from separate pieces. The DCM, as it was known, was an instant hit. By 1951, Herman Miller was selling 2,000 a month in the USA alone. A whole range soon followed – a wood-legged version, a hide-covered version, three-legged varieties and coffee tables – many of which are still in production today. The design is a twentieth-century classic.

The Eameses' philosophy was that good design should be available to all. Charles always said their aim was to bring "the most of the best to the greatest number of people for the least".

The DCM and its relatives were priced to appeal to a mass audience. The only range to really buck this trend was the last of the plywood chairs, the 1956 lounge chair and ottoman (originally created as a gift for their friend the film director Billy Wilder), which with their mix of plywood frame and upholstered leather seat were luxurious and pitched at a higher price. Nevertheless, these too sold in staggering quantity – Herman Miller had shifted 100,000 by 1975, netting itself $100 million.

It is not hard to understand why. There is something about the Eameses' furniture – a freshness, a simplicity, a sense of naturalness – that gives it an

The details are not the details, the details make the product.
Charles and Ray Eames, 1982

instant appeal, even today, over 70 years since the launch of the DCM. So how much more striking it must have been when it was first produced. It is no wonder that it was soon appearing on magazine covers, in advertising shoots, even on record sleeves.

The Eameses didn't confine themselves to plywood alone, though. They were soon experimenting with a range of materials. Some of the most elegant chairs they ever designed were made from plastic. The discovery of fibreglass-reinforced plastic (a material pioneered by the army) allowed the Eameses to crack the problem of the single-shell chair – lightweight but tough, it didn't snap. The single-shell chairs are masterpieces of economy – there's not a superfluous detail to them. Inexpensive (the stacking variety retailed at US$32), they sold in huge numbers.

Metal was perhaps a more obvious material to use. Designers such as Marcel Breuer, Mies van der Rohe and even Le Corbusier had been making furniture using bent metal since the 1920s and 1930s. The Eameses, however, gave the material a different spin. In 1951, they designed a chair not dissimilar in style to some of their plastic ones, but made from a lattice of wire mesh. Their friends the British architects Alison and Peter Smithson commented that the chair "hit us like a bombshell. It was very different – rather like the Eiffel Tower. You hadn't seen anything like it. It was extraordinary – it was light and yet it was metal. It was like a message of hope from another planet."

Not satisfied with one bombshell, they went on to design a cast aluminium chair. Again it was a huge hit. Architects have designed furniture, designers have created architecture: the Eameses were not exceptional in turning their hand to both. Where they were pioneering was in the sheer scope of their work. They didn't limit themselves to architecture and furniture design, they curated exhibitions, made films and co-ordinated multi-media events as well. The architect Kevin Roche described Charles as "without doubt the most creative and original designer of the twentieth century, combining ... the skills

of inventor, tinkerer, designer, architect, filmmaker together with those of scientist, researcher, visionary and creator – one who could make those far leaps and improbable connections of the true genius." Ray, though she got less acknowledgement for it, was just as multi-talented.

Exhibitions were an obvious extension of the Eameses' innate love of collecting and displaying objects. In 1950, they were commissioned to curate *Good Design* at the Chicago Merchandise Mart, an exhibition of functional everyday items – knives, forks, chairs and so on – which they displayed as though they were works of art. The show was a hit and was rapidly followed by a string of others including 1961's *Mathematica – A World of Numbers and Beyond* at the California Museum of Science and Industry; *Nehru: His Life and His India* in 1965, a travelling show; *The World of Franklin and Jefferson* in 1975, which also toured. Exhibitions allowed the Eameses to begin exploring their interest in multi-media. The shows were virtuoso performances – astonishingly potent cocktails that blended exhibits, graphics, text and interactive displays. Some, it is true, were criticized for "information overload" but all enveloped visitors in the heady world of their subject, whether it was India or maths. In an era where museums tended to display objects in glass cabinets, the Eameses injected a massive dynamism into exhibition design.

This way of communicating, this interest in telling a story through a number of media, bombarding the viewer with information, is something that architectural historian Beatriz Colomina believed distinguished the Eameses from their predecessors. She sees this tendency as much in their house at Pacific Palisades – with its paintings on the ceiling and objects on every surface – as she does in her exhibitions and films. "It is impossible to focus in the Eames House in the same way that we do in a house of the 1920s. Here the eye is that of a television viewer, not the one of the 1950s, but closer to the one of today," she wrote in 1997.

For designers living in Los Angeles, film – and increasingly television – were obvious paradigms as well as fascinating media in their own right. Charles had made films at Cranbrook and had worked part-time as a set designer for MGM in the early 1940s when he and Ray were struggling to get their studio off the ground. The pair knew many Hollywood figures and were soon playing around and experimenting with film for themselves.

Above. Charles and Ray Eames believed wholeheartedly in playfulness.
As well as designing numerous toys and games, and making films, they
frequently took part in performances.

First came the slide shows. The slide library at their Venice office groaned
under the weight of slides (there were 750,000 images in it on Ray's death,
when it was given to the Library of Congress). Charles pioneered the use of
multiple projectors, giving dazzling lectures rich in images. Among the most
extreme was his 1953 lecture to the University of Georgia entitled "A Rough
Sketch for a Sample Lesson for a Hypothetical Course". An attempt to
persuade the university to adopt a new method of teaching, it consisted of

three carousels of slides all running simultaneously; film, recorded sounds and smells were pumped into the university lecture hall through the air-conditioning system.

The best-known of the Eameses' multi-media performances was the 1959 Moscow film *Glimpses of the USA*. The project was commissioned by the US Department of State as part of a cultural exchange with Moscow. In a huge geodesic dome create by architect Buckminster Fuller, the Eameses projected 2,200 rapidly changing images onto seven 32-foot-long screens to a soundtrack created by Elmer Bernstein. Where some people might have chosen to emphasize America's wealth or power, the Eameses chose everyday life as their subject. The 12-minute show told the story of a journey across America in such beautifully poetic images that Peter Blake reported "everyone [had] tears in their eyes as they came out." The Eameses went on to make numerous films and other multi-media events.

The Eameses created films for themselves – such as their award-winning films about toys *Toccata for Toy Trains* (1957), *Parade* (1952) and *Tops* (1969) – and were commissioned by government departments and by business (notably IBM for whom they did a great deal of work). But even when working with the biggest of blue-chip companies, their approach was to educate and delight rather than to show off with flash effects and gimmicky ideas. Charles would often say "We have to take pleasure seriously." Pleasure for the Eameses was not to be found in luxury and expensive items but in pointing out and highlighting the beauty of everyday things and ordinary objects. For although neither Charles nor Ray was political in the sense of a strong allegiance to a particular party, a powerful political and moral message runs through their work – that design should not be an elitist exercise.

In many ways, Charles and Ray Eames established the idea of design as it is practised today. In their sheer brilliance they have not been superseded by many, but in the breadth of their ambition and their skill with a range of media,

Who ever said that pleasure wasn't functional?
Charles Eames

they established a multi-disciplinary way of working that many designers have since followed. Several generations of designers worked their way up through the Eameses' office to become well-known designers in their own right. Many more, like the British architects Norman Foster and Michael Hopkins, have been influenced by the Eameses' vision.

Given his hostility towards monographs, what Charles would have thought of the huge Eames retrospective organized by the Library of Congress and Vitra Design Museum in 1997 is anyone's guess. But the public loved it and it was not hard to see why.

Since the couple passed away, the Eames Office (which has incorporated several generations of the family, alongside a small staff) has kept the flame alive. Part of that remit is to ensure continuing authenticity. Furniture production is carried out faithfully by the two manufacturers who worked with Charles and Ray in their lifetime – Herman Miller (in the USA, from the late 1940s) and Vitra (in Europe and the Middle East, from 1957).

In 1990, Vitra debuted the La Chaise chair (designed in 1948). It was the first moulded plastic chair created by the couple, for that year's International Competition for Low-Cost Furniture Design, organized by MoMA. But the manufacturers' involvement makes it incumbent on them not only to stay faithful to the aesthetics and quality control that the Eameses insisted on during their lifetime, but also to contribute towards their legacy via publications and retrospective exhibitions.

The couple were enthusiastic travellers and embraced a holistic, inclusive world view. They designed for "the universal part of themselves", in a memorable phrase by Eames Office director Eames Demetrios (Charles's grandson), while film-maker Paul Schrader observed in 1970 that "The Eameses have constructed structures – a house, chair film – in which people can define themselves not by their idiosyncrasies but by their similarities." Given which, it seems entirely fitting that their work has been so widely embraced around the globe. Charles and Ray first visited Japan in the 1950s and maintained a mutually beneficial exchange with Japanese designers (both abroad and Stateside) over the years. Japanese aesthetics chimed with their own intuitive sense of clean-lined design and remained a touchstone. Reflecting that vibrant interchange of ideas, Japan has hosted notable

> They designed a system that would give you the same experience again and again. The chair that Herman Miller makes tomorrow is the same one that Eames originally designed; it's just as authentic.
> Eames Demetrios, interview with *Design Anthology*

exhibitions on the pair – 2002's *Eames Design* at Tokyo's Ueno Museum and *Eames Office: 80 Years of Design* at the city's Isetan The Space gallery in 2021–22, around 60 years since the Isetan store began selling Eames products. In 2015, the Eames Office had curated the exhibition *Essential Eames: The Design of Knowledge* specifically for Asia, a touring show that continues as of 2022.

The year 1998 saw the launch of the *Powers of Ten* exhibition, which explored the remarkable film of the same name; it went on to be staged in eleven cities across five countries and joined The Library of Congress's National Film Registry in 1999. Another famous exhibition, 1961's *Mathematica*, toured again in 2001 and is now on permanent display in three institutions: Boston's Museum of Science in Massachusetts, the New York Hall of Science and, most recently, the Henry Ford Museum in Dearborn, Michigan.

Elsewhere, the Melbourne Design Festival played host to a 50th-anniversary exhibition of the Eames lounge chair and ottoman in 2006, curated by Charles's granddaughter, Carla Hartman, while a standout Eames exhibition opened at London's Barbican gallery in 2015: *The World of Charles and Ray Eames* offered a comprehensive tour of their achievements and later toured Europe before transferring to the USA.

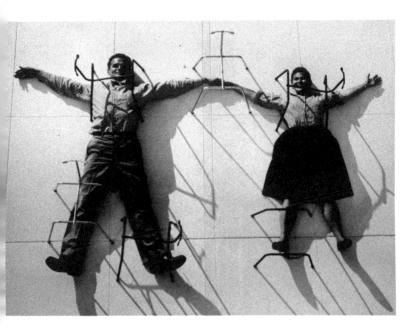

Above. Charles and Ray Eames "pinned" by chair bases, 1947.

Sometimes, the shifting sensibilities of the times has warranted a subtle modification of an original design. In 1993, for example, Herman Miller opted to begin using cherry and walnut from sustainable sources for the Eames lounge chair and ottoman, rather than endangered rosewood.

On other occasions, it might mean sanctioning a new collaboration with the Eames imprimatur, some of which might have delighted, or at the very least surprised, Charles and Ray themselves. These have included a partnership with Maharam in 1990 to produce upholstery fabrics, but also new ranges of Reebok sneakers (2021–22) and a limited-edition skateboard deck with Globe (2021) – its eucalyptus wood carved from a tree that had stood near the Eames House but had begun to present a risk to it.

The couple's love of play, and learning through play, would surely have seen them endorse the designer playing cards and series of puzzles, with Art of Play and Ravensburger respectively, in 2021–22. And who could fail to be

The Eames aesthetic brought art into the marketplace through the assembly line.
Paul Shrader, *Film Quarterly*, 1970

charmed by the reissue of the Eames Plywood Elephant, launched in 2007 to mark the centenary of Charles's death? (Prototypes were created in 1945, but never entered production, stymied by marketing shortcomings.)

At the core of the Eames's working practice was an ingrained belief that good design should be available to all. Seen in that light, some of the more recent product releases might raise an eyebrow. Vitra's La Chaise (1990; currently £7,650) for example. Ditto that Eames Elephant – currently retailing at nearly £1,400 per wooden pachyderm (although plastic models are available for around £200, and around half that for the smallest variant). Or the prohibitively expensive Plywood Sculpture, based on an original 1943 design, that featured in Isetan's selling exhibition in 2022. Available in a (very) limited edition of 12, it was strictly aimed at collectors. "It is [their] concern for mutual understanding and accessibility that shapes much of the Eames approach: materials and methods to reach a large audience," noted a Royal Academy blog in 2015, in the context of the Barbican's *The World of Charles and Ray Eames* show. "Given the elite status of the furniture designs that are still in production, how much they achieved that accessibility is debatable."

As a counterargument, however, it's worth noting that in addition to meeting their own everyday running costs, the Eames Office has the responsibility of conserving the much-loved Eames House – which was made a National Historic Landmark on 17 June 2007, on what would have been Charles's 100th birthday (and Ray's 95th). Ray was keenly aware of the need to maintain the iconic building and gave it to her step-daughter, Lucia Eames. In turn, Lucia gifted it to the non-profit Eames Foundation, which she established 2004 specifically to preserve the house.

One of the most refreshing aspects of the couple's legacy has been the recognition of Ray's own considerable talents and her role in the couple's

dynamic working partnership. In 2008, the Art Directors Club in New York made Ray a Hall of Fame laureate – an honour reserved for "innovators who represent the highest standards of creative excellence". It was long overdue (Charles was inducted in 1984), and saw Ray join an illustrious company that also includes Bauhaus leading light László Moholy-Nagy, graphic designer and Oscar winner Saul Bass, photographers Richard Avedon, Norman Rockwell and Annie Leibovitz, and American icons Walt Disney and Andy Warhol.

That same year saw the Eames Office Gallery host the exhibition *Ray Eames: Notes for a Celebration*, while the office also oversaw the 2014 show *Ray Eames in the Spotlight*, which opened at the Alyce de Roulet Williamson Gallery in Pasadena, California. And there are ongoing plans, supported by the office, to create Ray Eames Park in her birthplace, Sacramento.

Posthumous publications are also doing their bit to distinguish Ray the painter from Charles and Ray Eames the double-headed design beast. The year 2000 marked the appearance of *Changing Her Palette: Paintings by Ray Eames* – a fascinating glimpse of her early creativity that provided a catalogue for a show at the Eames Office Gallery and Store and which was edited by Eames Demetrios.

Ray herself had initiated the weighty monograph *Eames Design*, a chronological overview of the couple's oeuvre, published by Abrams a year after her death. Through numerous publications, exhibitions and other media (such as Eames Demetrious's TED mainstage talk on "The Design Genius of Charles + Ray Eames" in 2007), the couple's vision of the world becomes codified, something to be studied – witness the title of the 2001 book *An Eames Primer*. The Eameses long ago became transmuted into a brand, one that embodies not only exacting standards in design, but also an overarching outlook on life,

Charles introduced modernist design to middle America, but it was Ray who softened its hard edges, and gave it mass appeal. William Cook, bbc.com, 2017

a philosophy. Their concise, epigrammatic comments on their work offer almost Zen-like observations – "Who would say that pleasure is not useful?"; "The details are not details. They make the product" (both from Charles). Like the films they made, they were informed, accessible and to the point, and it seemed entirely appropriate that a selection of their pithy observations should be gathered for the publication *100 Quotes by Charles Eames* (2007).

The Eameses' furniture and home accessories can be found in more than forty museums worldwide. In a practical sense, however, we're still living with their legacy on a day-to-day basis. Think of the inexpensive, flat-packed furniture we flock to Ikea, or the US firm Crate & Barrel, to buy at weekends. (Ikea's adoption of plywood for furniture harks back not only to Scandinavian heritage but to its primacy in the work of 1950s designers such as Arne Jacobsen and the Eameses.) Meanwhile, variations on their tandem sling seating are still a feature of airport lounges worldwide.

All are continuing reminders that Charles and Ray's carefully considered designs still fulfil their original remit admirably – and have offered a reliable template for fellow professionals since. Braun's designer Dieter Rams has namechecked the Eameses as an inspiration, their insistence of marrying form with function, and that infectious sense of play; his 620 lounge chair is just one example. In turn, Rams's aesthetic (along with that of the Bauhaus, inevitably) was a formative influence on Jony Ive, who served as senior vice principle of industrial design at Apple, becoming chief design officer in 2015.

It's possible to trace a thread from their home, the Case Study House 8 at Pacific Palisades through to modern-day prefab designs, such as Philippe Starck's eye-catching P.A.T.H. houses. True, kit houses had been a feature of the North American housing market since the early decades of the twentieth century – familiar enough by 1920 to form the basis for Buster Keaton's silent-movie classic *One Week*, in which his attempts to erect a self-build home are constantly thwarted. Yet by and large, these designs were more conventional, with sloping roofs and discrete door and window spaces.

By contrast, the Eameses' home sported double-height spaces, an abundance of glass and was defiantly flat-roofed and right-angled, effectively two boxes separated by a courtyard. The De Stijl movement was a palpable influence, not least in the sliding windows and partitions, which created a

versatile, adaptable space. All of which made it too radical a proposition – too futuristic or redolent of European modernism, perhaps – to be widely adopted Stateside at the time. Its spiritual brethren there were the likes of the Farnsworth House (completed 1951), designed by Mies van der Rohe, and Philip Johnson's Glass House (completed 1949), but those were exclusive projects built for moneyed clients (Edith Farnsworth) and the architect himself, rather than as a relatively inexpensive prefab, which Case Study House 8 was intended to represent.

In Charles and Ray's time, the onus was on producing affordable, practical homes to address a housing crisis in post-war America, exacerbated by veterans returning from the war. In 1951, they designed a one-storey modular house – another low-cost prefab – to the same end, with a gracefully curving roof atop an open-plan interior. (Never built, it was featured as a scale model in an Eames exhibition at Isetan The Space in Tokyo, in 2021–22.)

Today, the driving force is a shortage of affordable, sustainable, environmentally sensitive housing. Prefabs and modular homes have been enjoying something of a renaissance (prompted, in part, by the ongoing popularity of home-design TV shows), and many contemporary options incorporate expanses of glass, squared-off designs and open interior spaces that the Eameses and their forward-thinking contemporaries would have recognized. Philippe Starck's prefabricated P.A.T.H. homes offer a range of eco-technology innovations to minimize energy costs and reportedly take just two weeks to construct, after delivery. But both reflect imaginative responses to the demands of their time. And though Starck's scheme may currently only be feasible for those with middle-class budgets, if it proves practical, and attracts buyers in sufficient numbers, those pioneering features may become adapted into more broadly affordable, mass-produced iterations over time.

But it might well be the visual media that the couple created (including some 125 short films) that has had the most lasting impact. Slides and cinema offered the couple the opportunity to present compressed information and complicated ideas in an entertaining way, something that anticipates today's short-form social-media platforms such as TikTok and Instagram.

The 22-minute short *Think*, created for IBM's installation at the 1964–65 World's Fair in New York, explores problem-solving across a range of different

scenarios, including financial transactions, play strategies in American football and plans for railway networks. Elsewhere, they took familiar objects, perhaps so familiar as to have blended into the background, and looked at them afresh, bringing out their uniqueness and individual integrity. And after the Eameses showed *Glimpses of the USA* on a septet of screens within a Buckminster Fuller geodesic dome, Fuller not only applauded their originality but pointed out the potential appeal of multiple visuals to advertisers and movie-makers. Charles and Ray applied the same relentless eye for detail here that they applied to designing new products: diversifying the visual messaging by employing multiple screens, mixing and matching stills with moving images, incorporating bespoke soundtracks.

One of the first commentators to pick up on their prolific and ground-breaking film work was Paul Schrader. Then a graduate of the UCLA film school, and a movie critic for the underground newspaper *Los Angeles Free Press*, Schrader visited their office at 901 Washington Boulevard and marvelled at the office's lack of convention and abundance of creativity. Schrader, whose screenwriting credits include *Taxi Driver* (1976) and *Raging Bull* (1980) – both for Martin Scorsese – cited Charles as his prime inspiration for becoming a film-maker, and observed that what the Eameses were creating was unique in cinema. His 1970 article on Charles for *Film Quarterly* (Ray's contribution is all but overlooked) was titled "Poetry of Ideas", a description that might equally be applied to the couple's work as a whole.

Schrader drew attention to what he termed the "information overload" in the Eames's movies – witness the images appearing across multiple screens in *Glimpses of the USA*. In an interview towards the end of the piece, Charles had reservations about that word "overload" but conceded to using simultaneous imagery "in a way that heightens the reality of the subject", an attempt to capture the *thingness* of a thing in a way that aroused an emotional resonance within the viewer. Carefully edited and orchestrated, incorporating rapid cutting, the pictures flickering across those seven screens were thematically choreographed, showing related content from different perspectives and locations.

"Because the viewer is being led at the cutter's pace, it can, over a long period, be exhausting. But this technique can deliver a great amount of

What works good is better than what looks good, because what works good lasts.
Ray Eames

information in much the same way we naturally perceive it – we did this pretty consciously."

Although the couple couldn't have known it at the time, such innovations were anticipating the world we live in today, where we rely on a variety of screens throughout both working hours and leisure time, from our computer to the train station to our mobile phones. No longer exclusively tied to prolonged engagement with a single source or narrative, we take in simultaneous imagery, and are faced with multiple information streams on a daily basis. It's something that Beatriz Colomina observed in her perceptive essay "Reflections on the Eames House" (1997), noting that the building's content-rich interior was something that a contemporary TV watcher would intuitively understand: "looking at multiple screens, some with captions, all simultaneously. It helps to follow more than one story at once."

As some commentators have pointed out, such "overload" might be used to debatable ends (*Think* and *Glimpses of the USA* were commissioned by a corporate tech giant and the US government, after all). But more positively, it might equally recall the visual "clutter" with which Charles and Ray populated that Pacific Palisades home – a live-in cabinet of curiosities born of their innate playfulness and willingness to engage with a broad spectrum of ideas. Qualities that characterized their prolific work in all its myriad forms, and which might be summed up as: "Look at *this*!"

Overleaf. The house that Charles and Ray designed at Pacific Palisades – one of the iconic houses of the twentieth century – proves their breadth as designers.

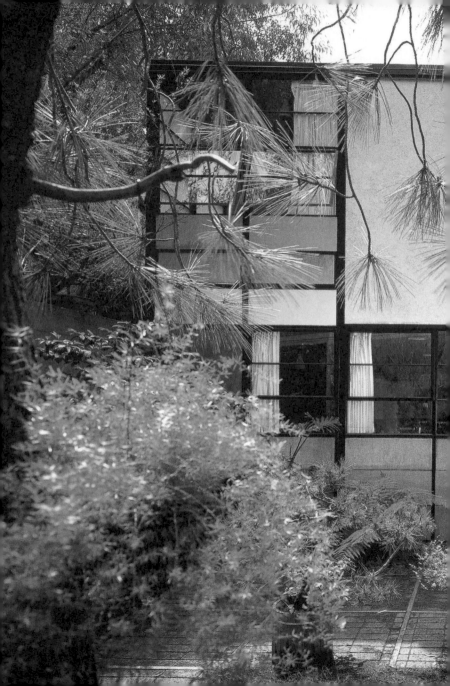

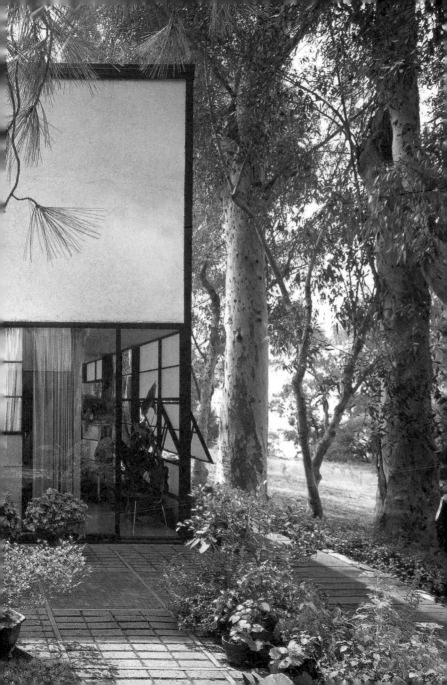

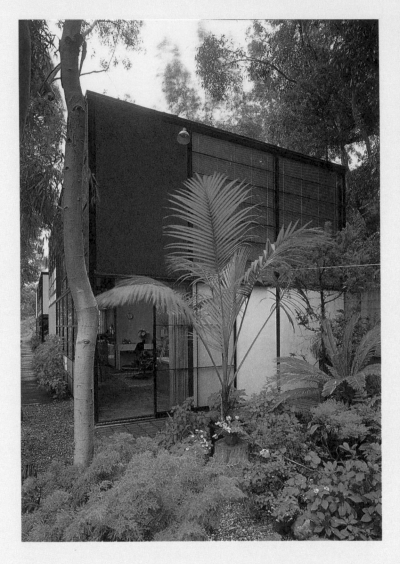

[01, 02, 03, 04, 05] The Eames House. Off-the-peg materials were put together in such a way that the effect was revolutionary. The building has been described as a "Mondrian-style composition in a Los Angeles meadow".

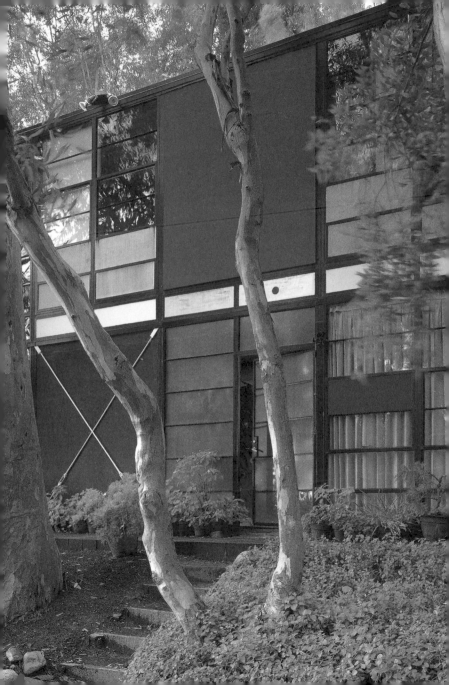

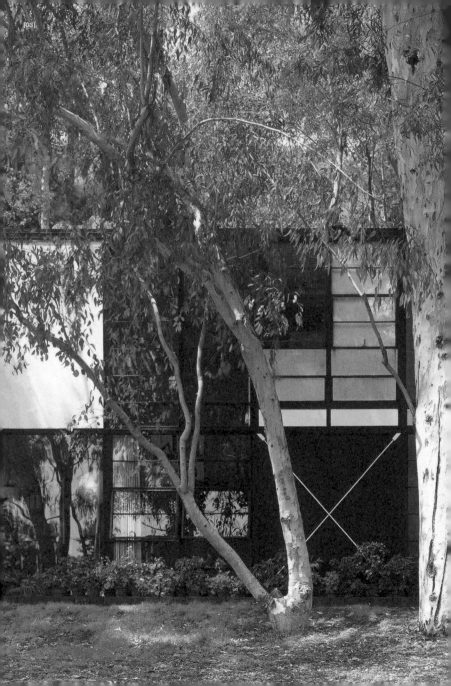

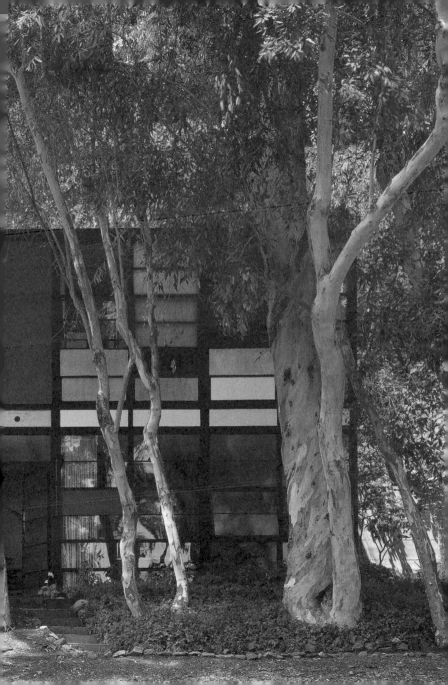

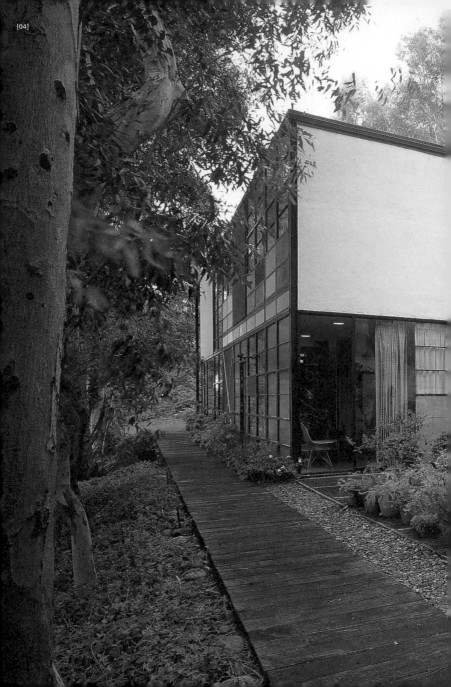

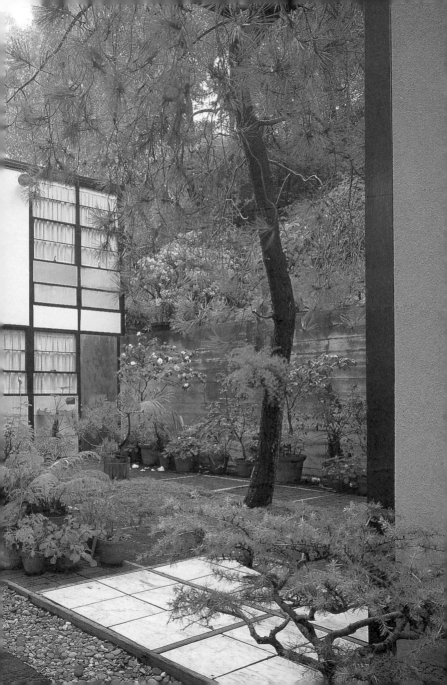

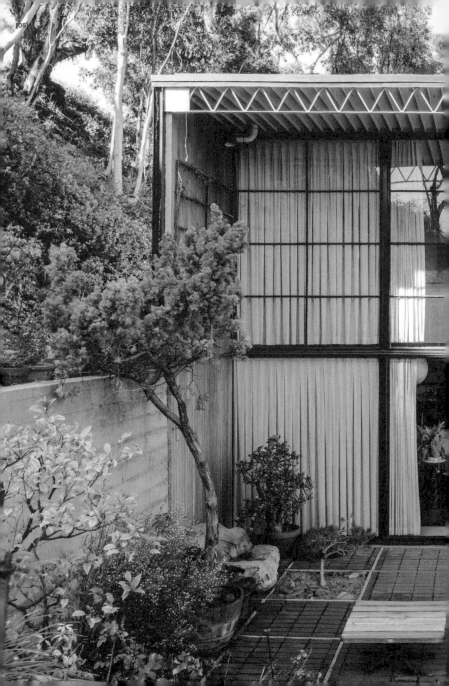

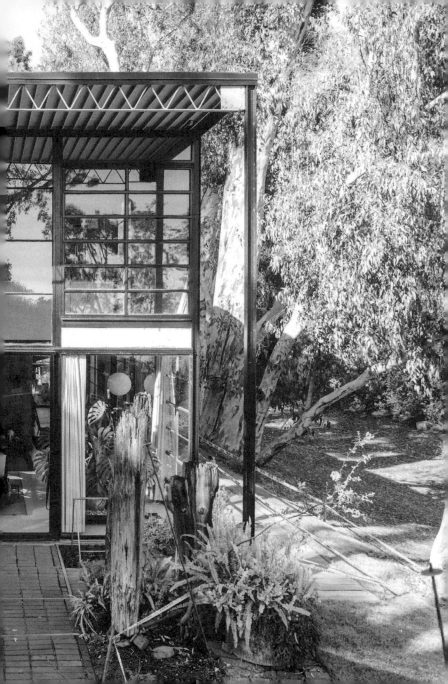

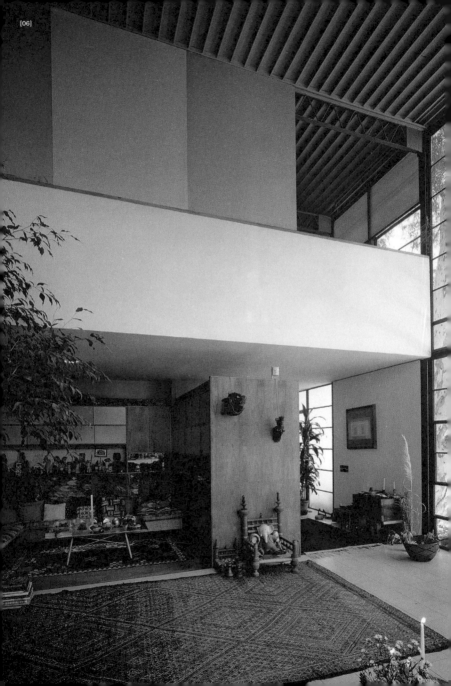

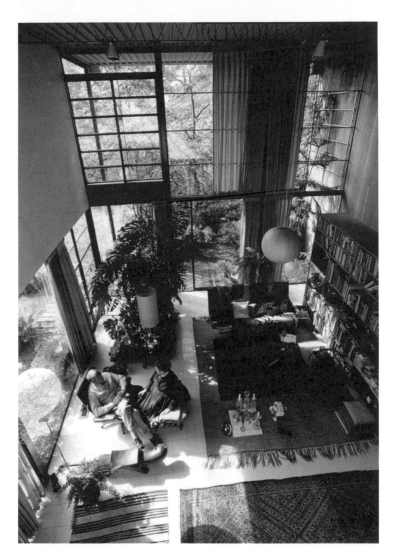

[06, 07] Inside, Charles and Ray filled the house with their impressive collection of *objets d'art*.

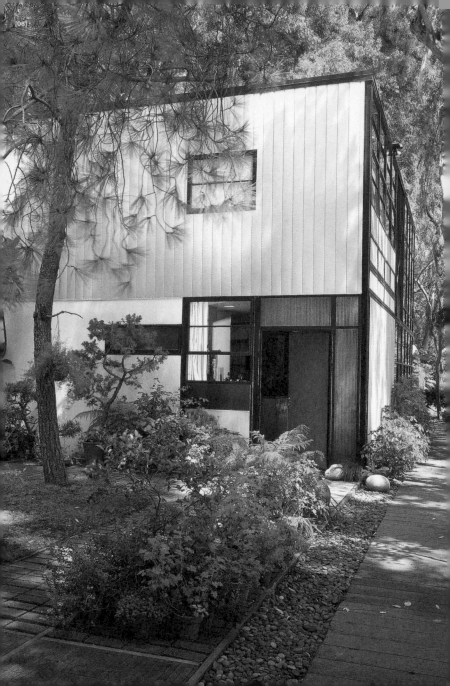

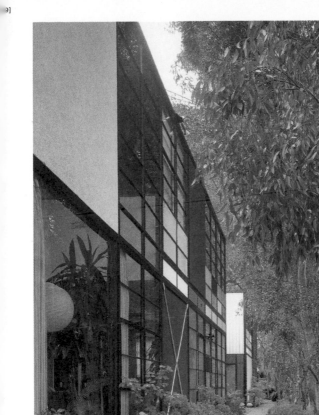

[08, 09] Next to the house was a studio, a laboratory where Charles and Ray could experiment and develop new ideas.

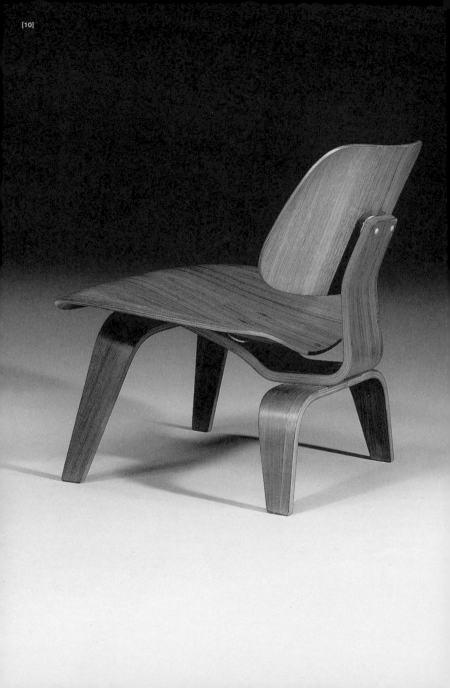

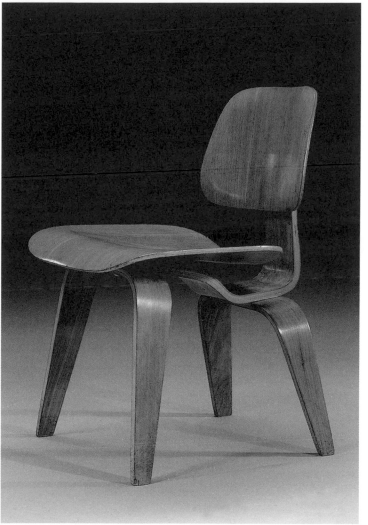

[10, 12, 13] The lower Lounge Chair Wood (LCW) and [11, 14] the Dining Chair Wood
(DCW) of 1945. Single-shell plywood chairs tended to snap, but the DCW and LCW, with
their separate back pieces, were an ingenious response to the problem.

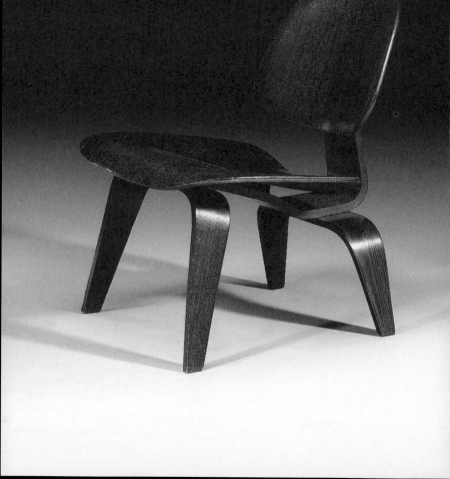

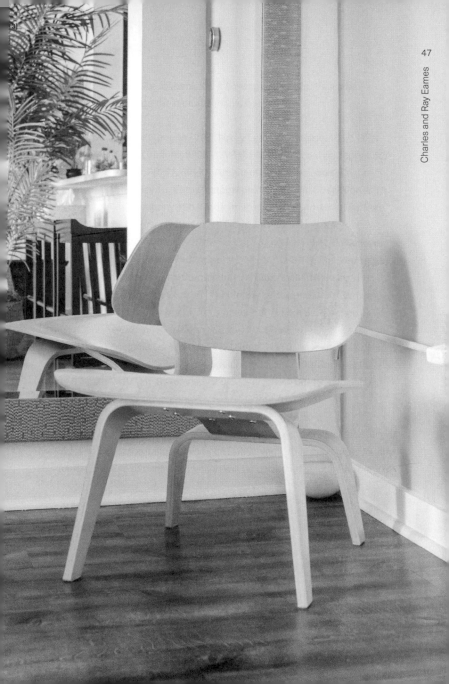

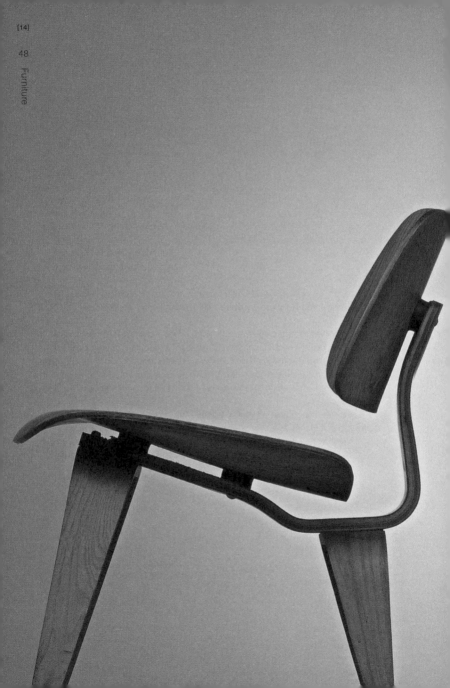

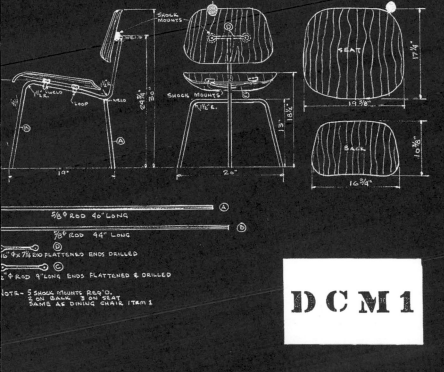

SHOCK MOUNTS

WELD

WELD

SHOCK MOUNTS

WELD

LOOP

WELD

SEAT

17¼"

19⅜"

BACK

10⅞"

16¾"

24¼"

30"

18½"

13"

19"

20"

Ⓐ
5/8 φ ROD 40" LONG

Ⓑ
5/8 φ ROD 44" LONG

Ⓓ
16" φ x 7¼ ROD FLATTENED ENDS DRILLED

Ⓒ
½" φ ROD 9" LONG ENDS FLATTENED & DRILLED

NOTE- 5 SHOCK MOUNTS REQ'D.
2 ON BACK 3 ON SEAT
SAME AS DINING CHAIR ITEM 1

D C M 1

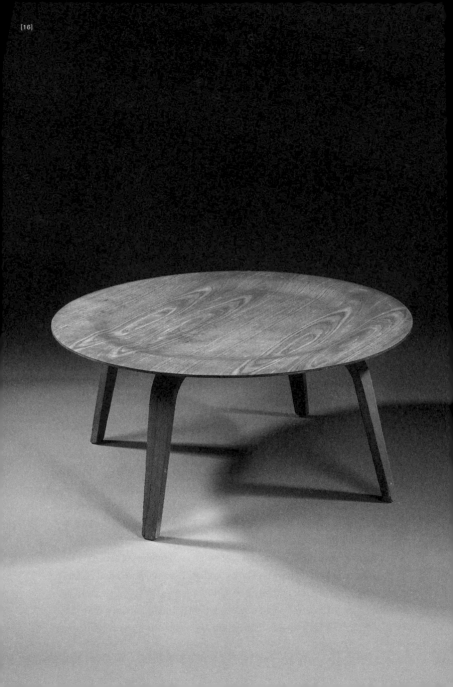

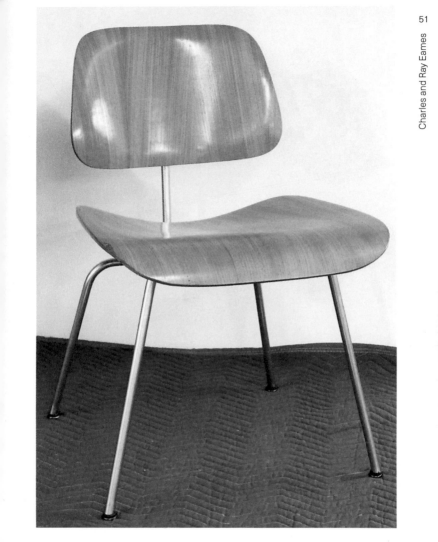

[15, 17] The Dining Chair Metal (DCM) was hugely successful and has been in continuous production since 1946. [16] The low occasional table came in two designs to match the DCW and the DCM.

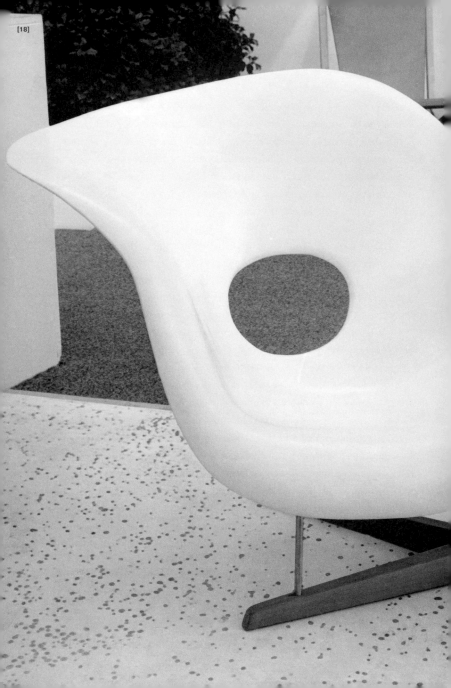

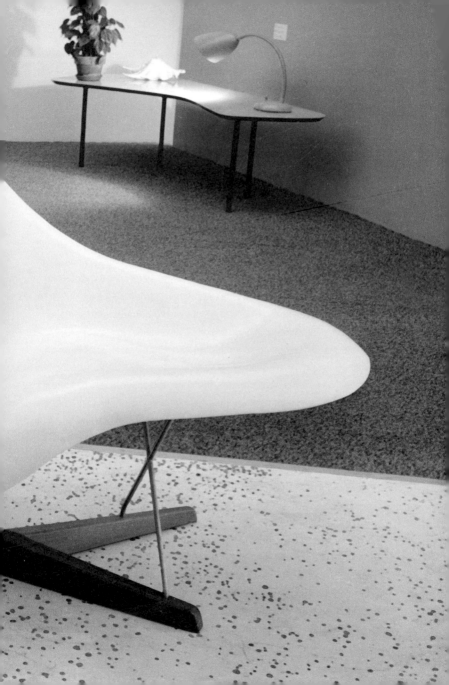

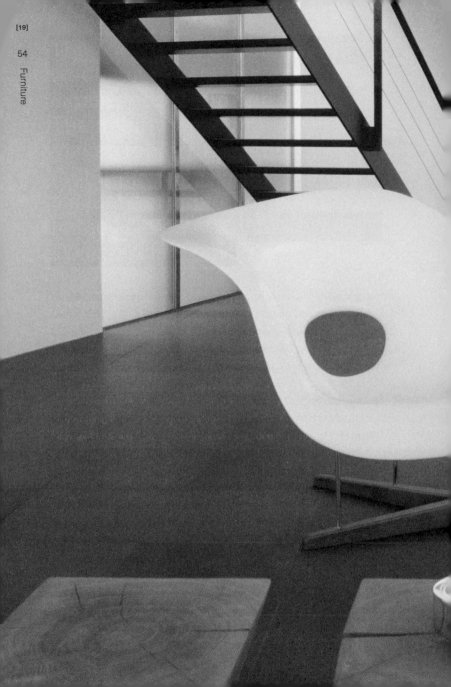

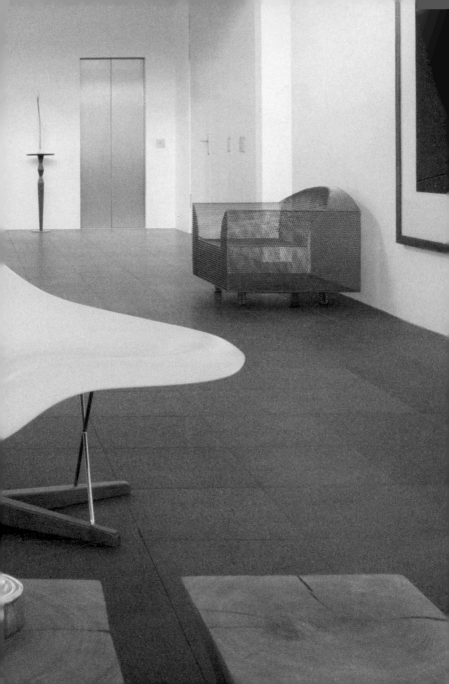

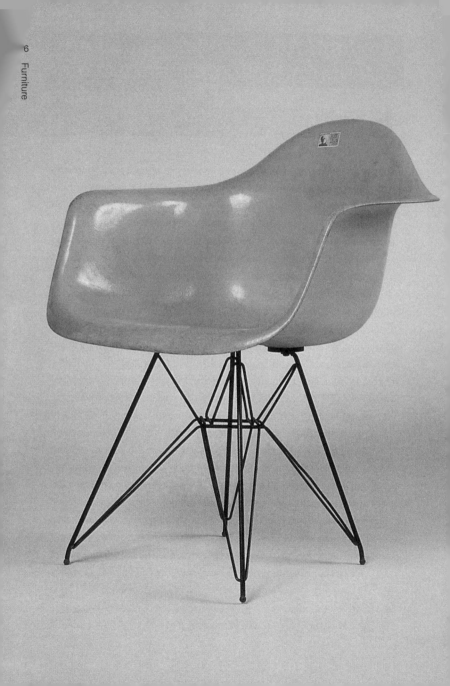

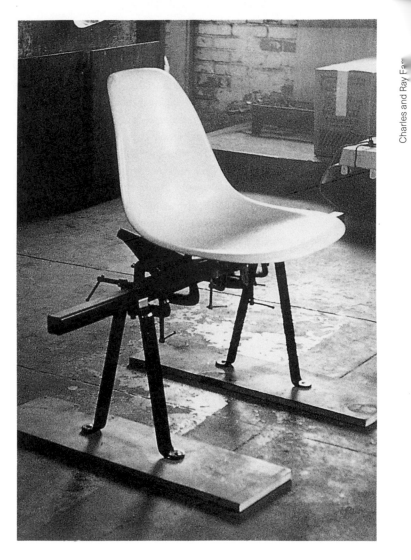

[18,19] La Chaise. A prototype designed for the Museum of Modern Art's International Competition for the Low-Cost Furniture Design show in 1948, and a modern version in a contemporary setting. [20] Dining Armchair Rod base (DAR) fibreglass armchair, 1950. [21] The discovery of fibre-reinforced plastic enabled the Eameses to make strong single-shell chairs. [22, 23] The DAX metal base, in fibreglass and upholstered versions.

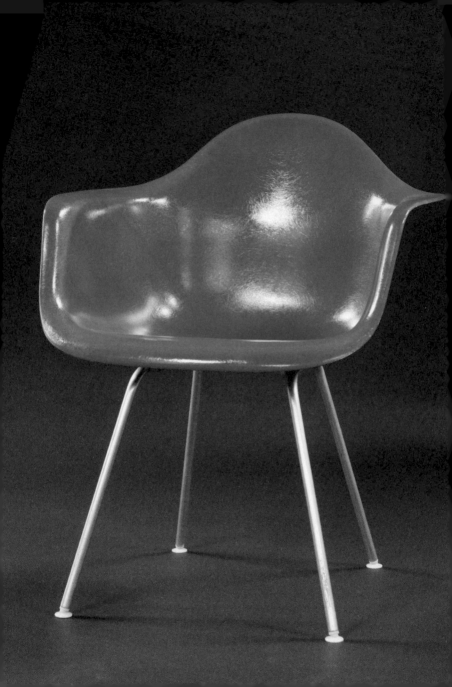

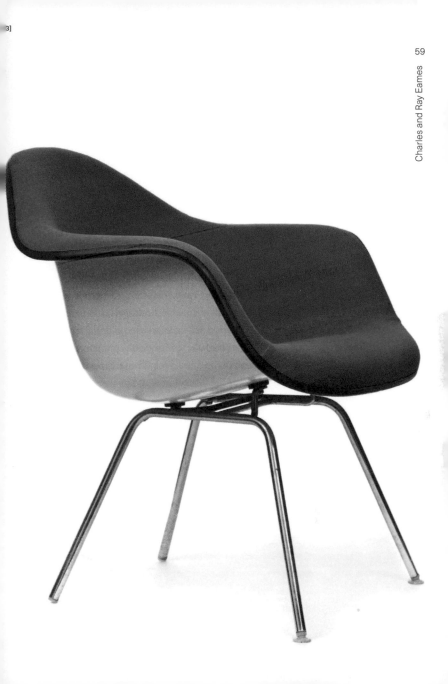

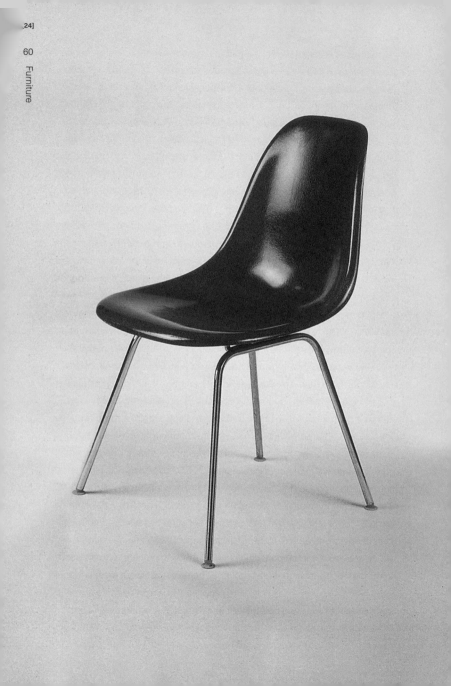

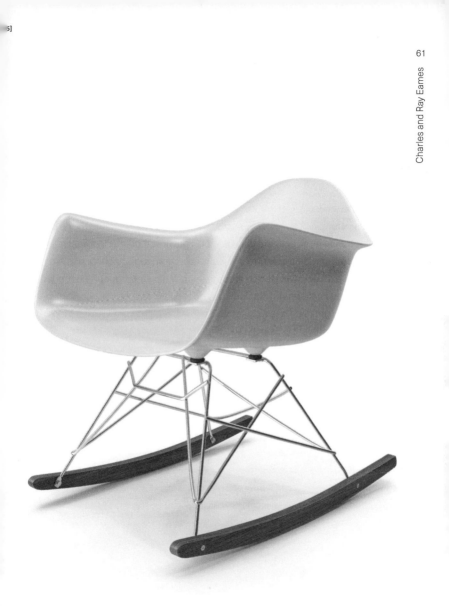

[24] Single-shell DSX chair, with the H metal base that was launched in 1954. [25, 26] The Rocking Armchair Rocking base (RAR) chair. [27] Moulded single-shell and wire chairs in various colours from Vitra, 2019.

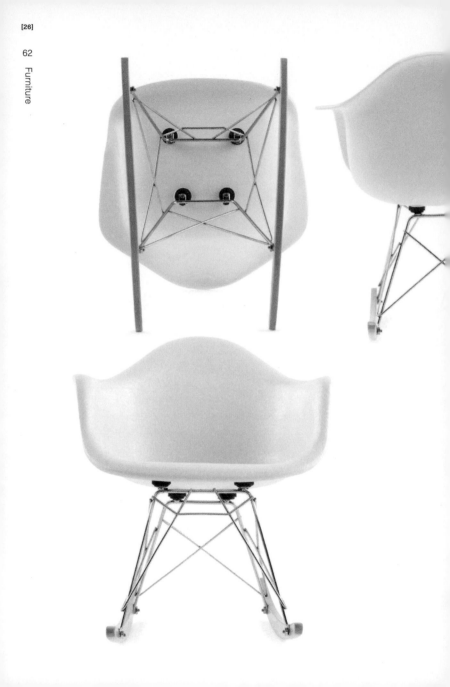

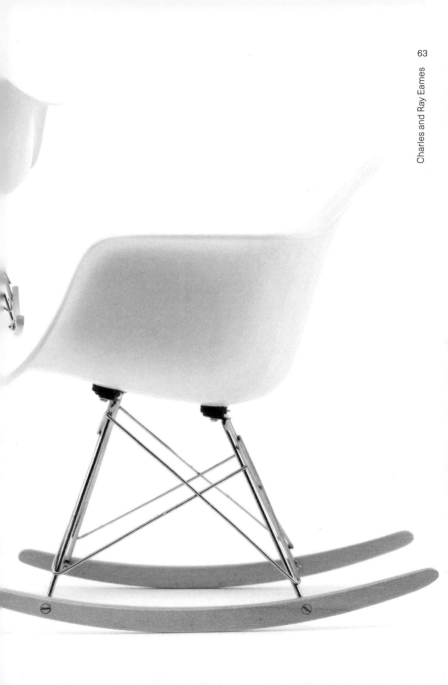

EAMES SHELL CHAIRS Created out of 14 plastic shells, 9 fiberglass and 35 Hopsak colours

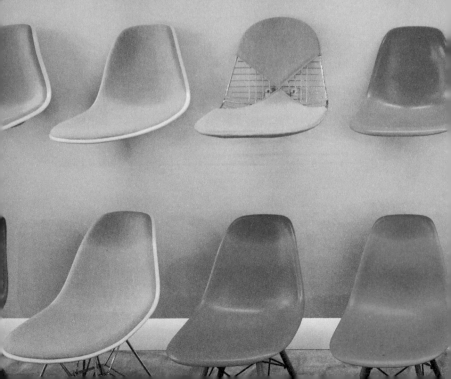

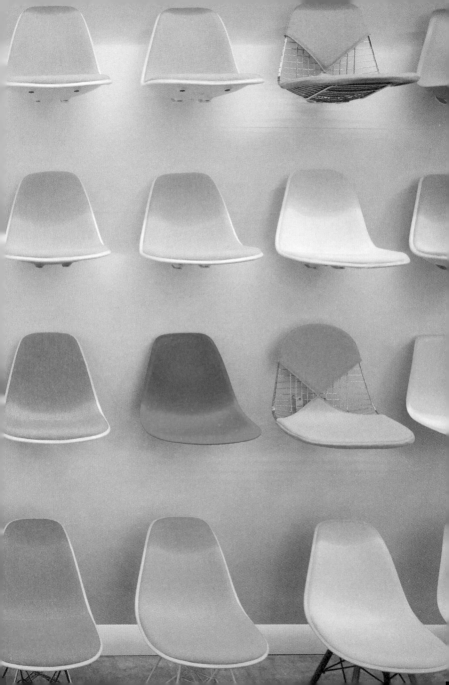

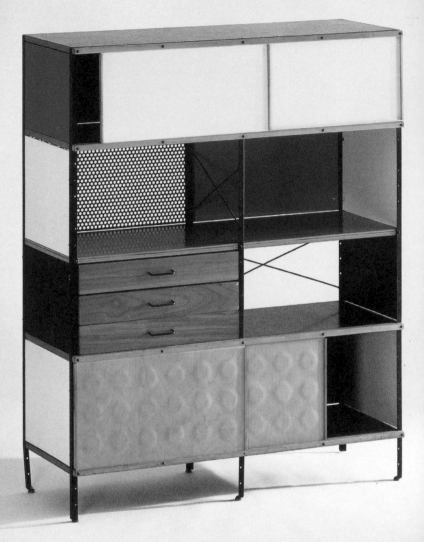

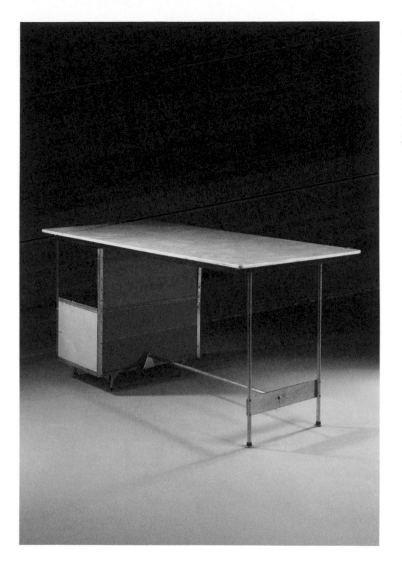

The Eames Storage Units (ESU) [28] and desk system (EDU) [29], released in 1950, were admired by designers but never sold as well as the chairs.

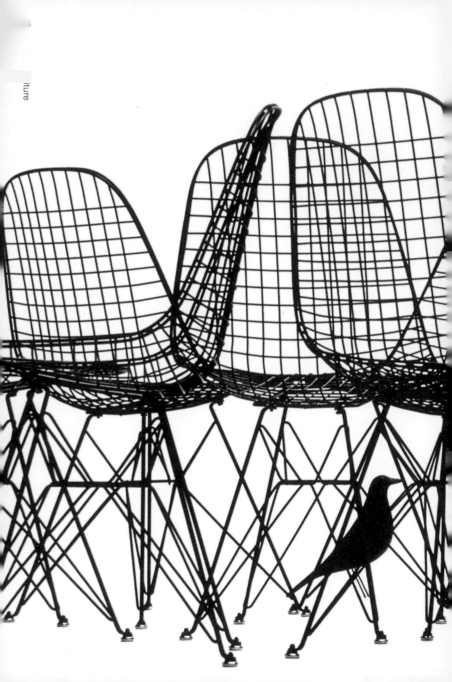

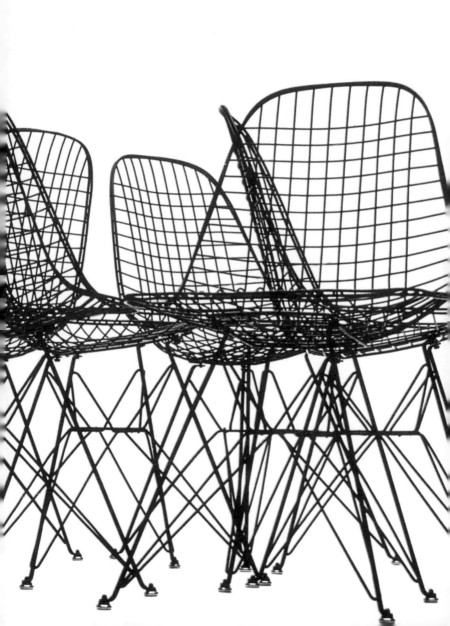

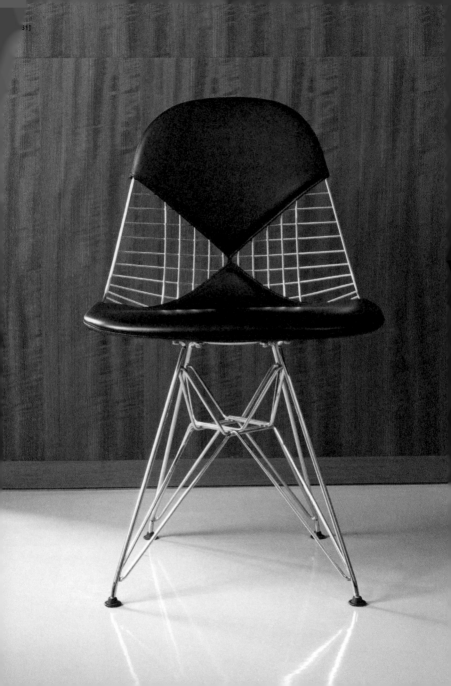

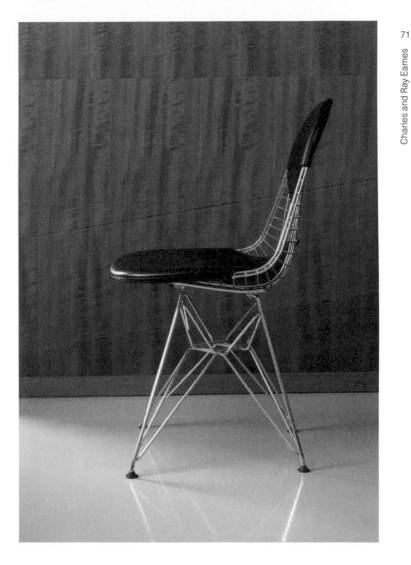

[30] The 1951 DKR wire chair (with "Eiffel Tower" base) was a radically new way to use the material. [31, 32] The DKR with the "bikini" pad.

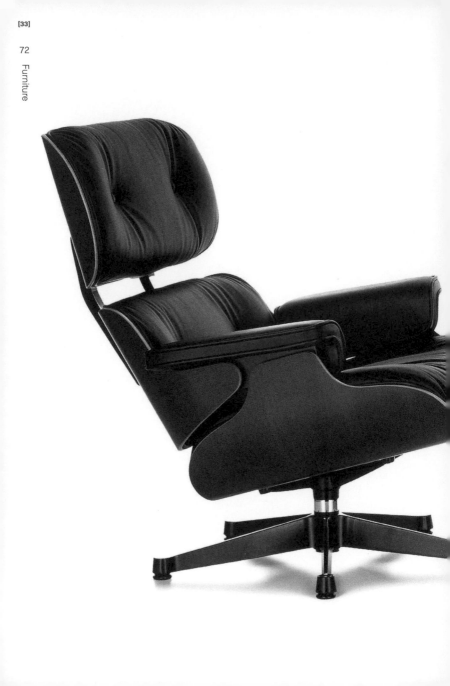

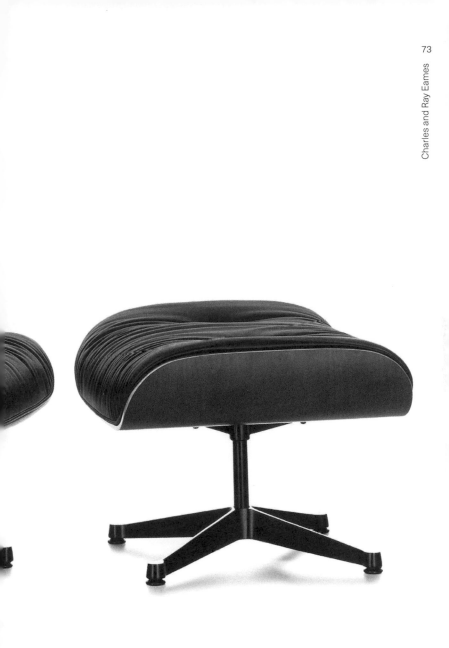

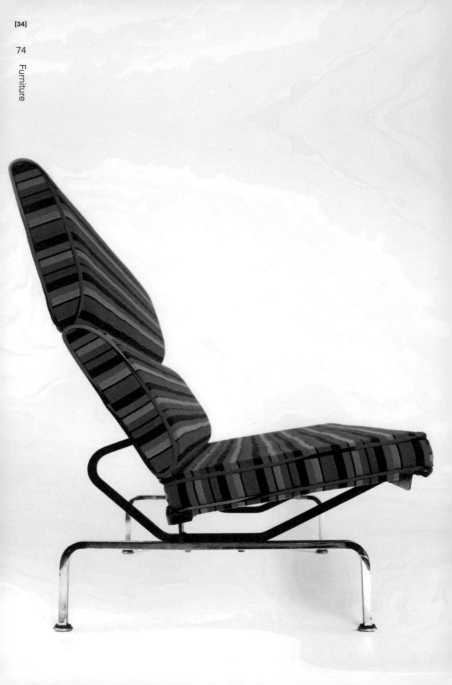

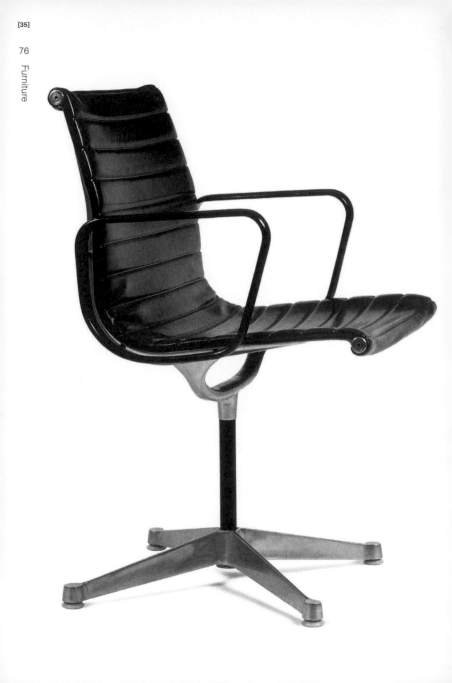

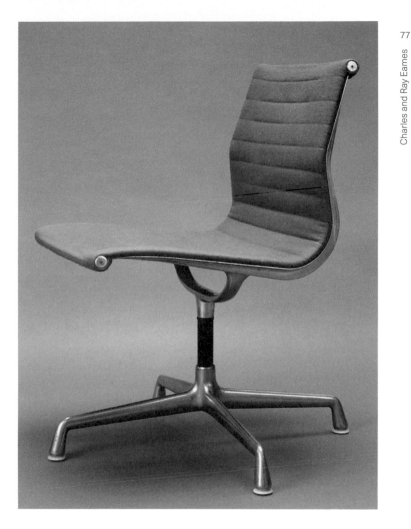

[33] Lounge chair and ottoman. Designed in 1956, this is one of the more luxurious of the Eameses' chair designs. [34] Eames Sofa Compact, 1954. [35, 36] The aluminium EA chair from 1958, made by stretching a panel of fabric or leather to create a taut seat that adapts to the body of the sitter; and in 2014 colours by Vitra [37].

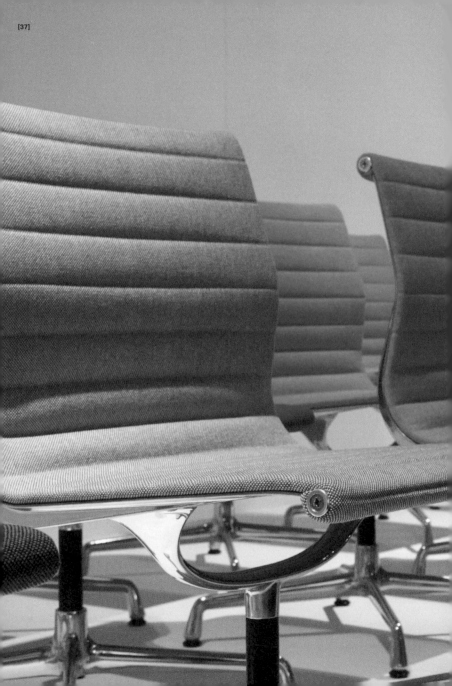

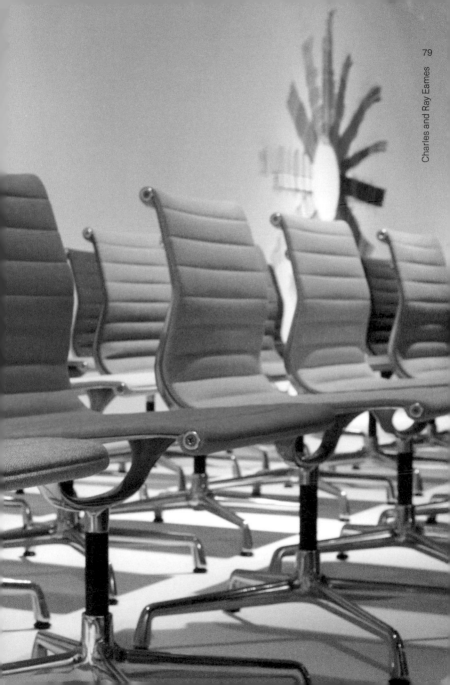

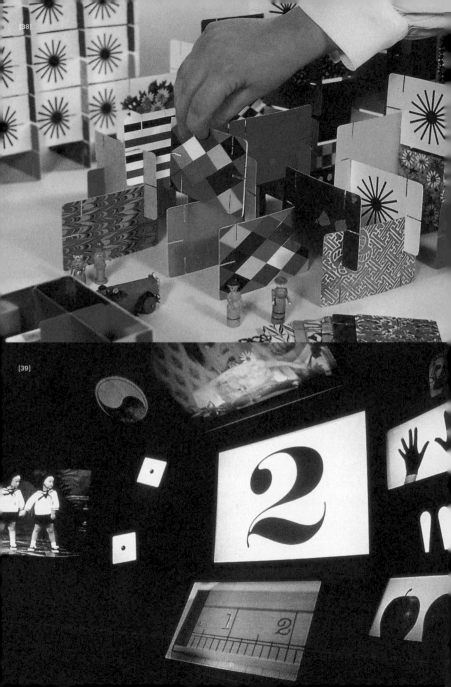

[38, 40] Learning through images. The 1952 children's game the House of Cards.
[39] The 1964–65 *Think* exhibition for IBM used images to stimulate people's
imagination. [41] Charles Eames with a solar-powered, kinetic metal sculpture
with optical and sound effects, 1958.

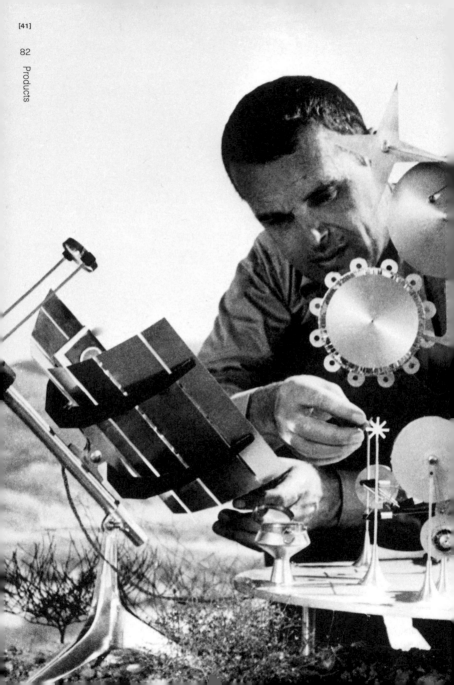

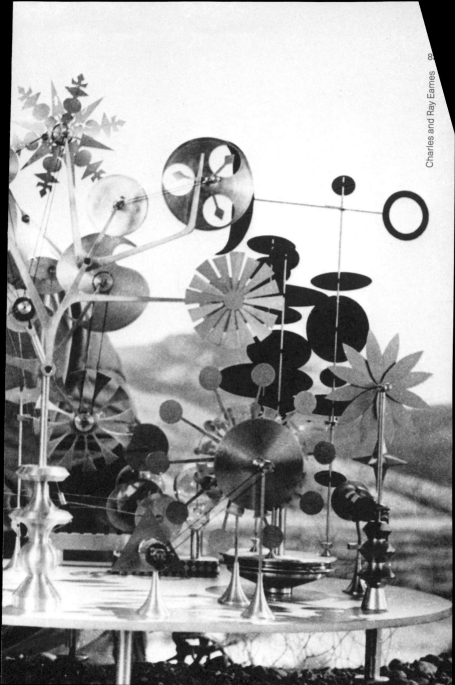

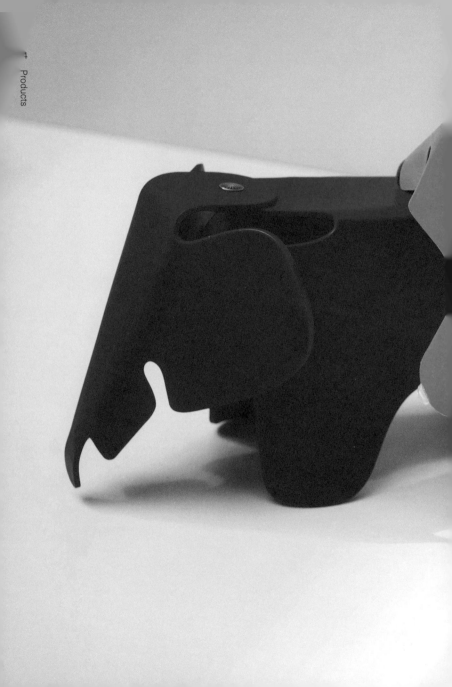

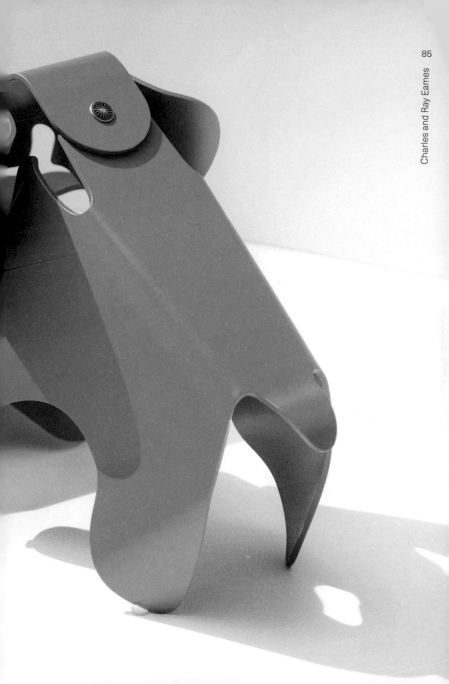

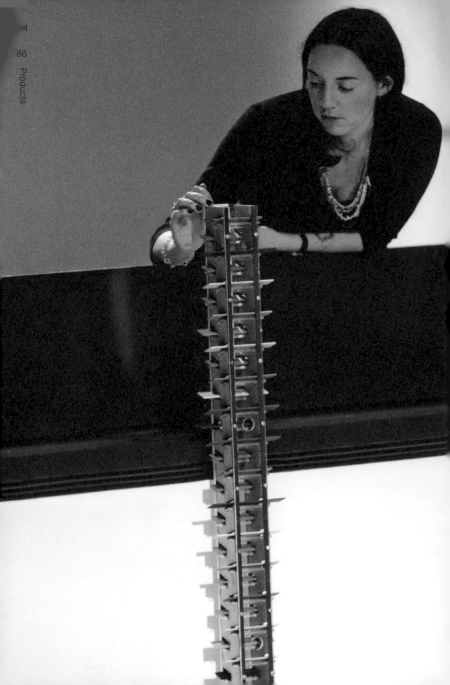

[42] The Eames Elephant was created from plywood around 1945; today it is also available in colourful plastic, as here. [43] The Musical Tower, from the 1950s, is a vertical xylophone; music plays when a marble ball is dropped into a slot at the top. [44] An early paper collage dating from 1943 by Ray, who was a talented artist in her own right. [45] The couple shooting a film, undated. [46, 47] *Toccata for Toy Trains* film, 1957. [48, 49] *Tops* film, 1969.

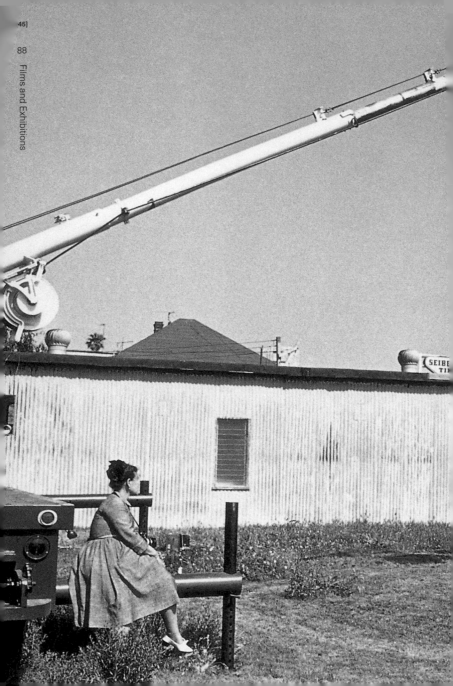

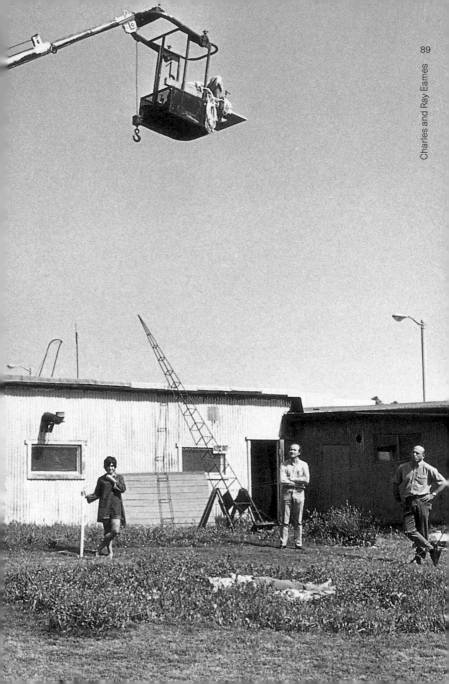

[46]

[47]

2

8]

[49]

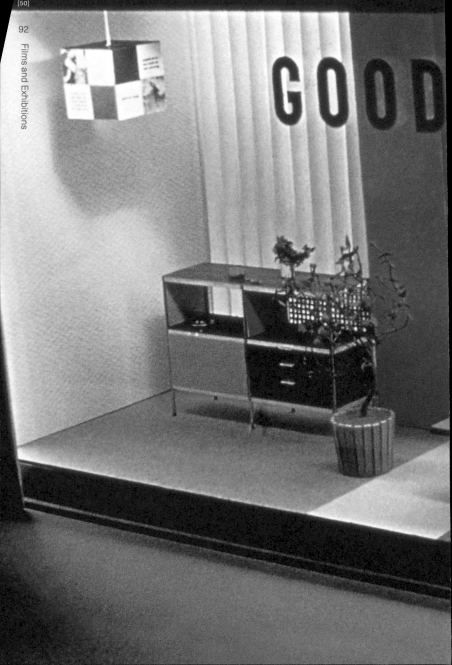

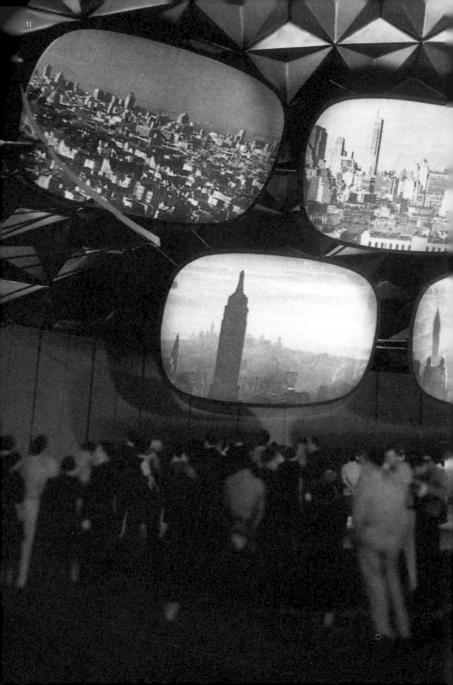

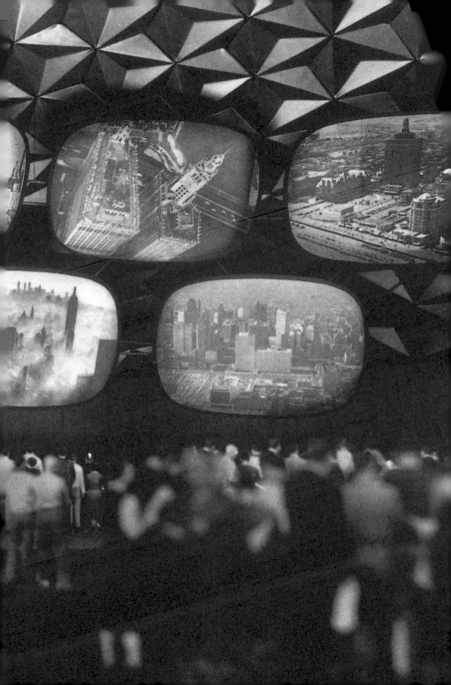

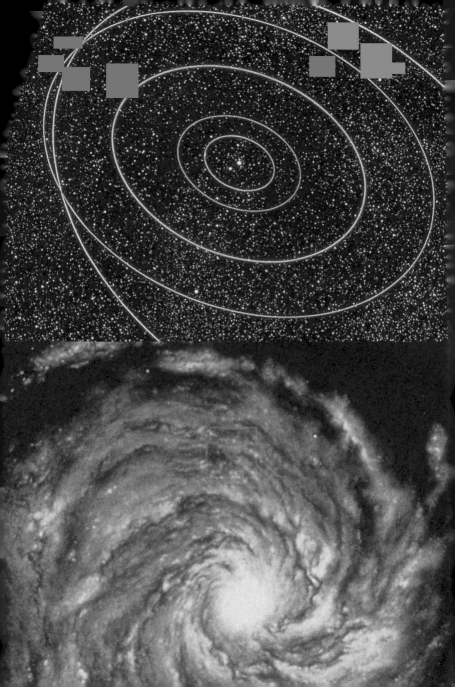

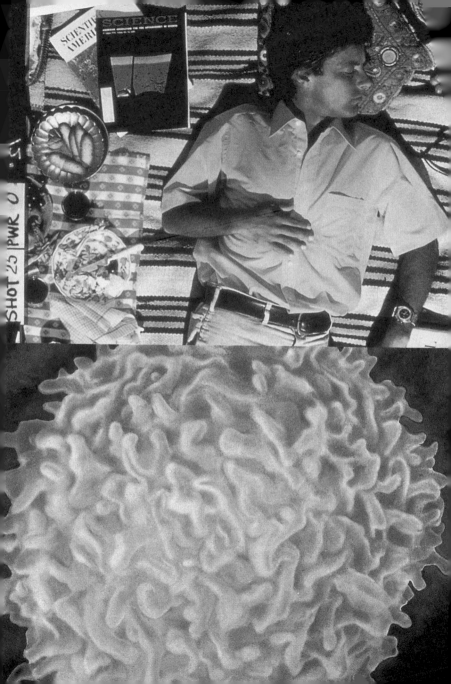

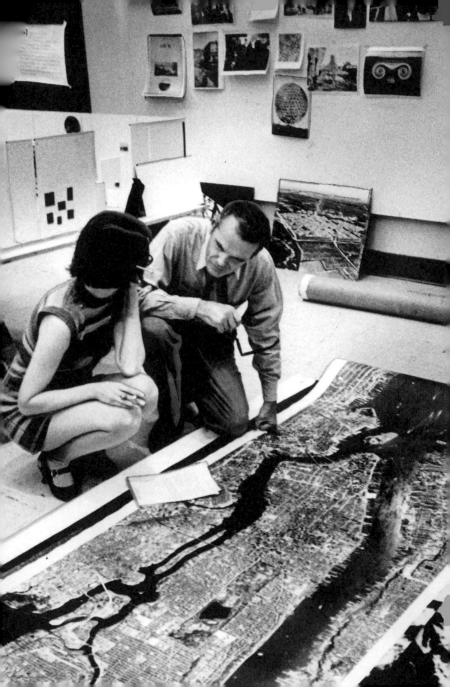

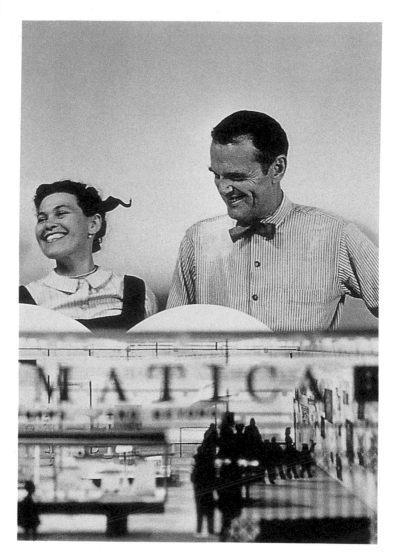

[50] *Good Design* show, 1950. [51] *Glimpses of USA* film, 1959. [52] *Powers of Ten* film, 1977. [53] Charles Eames and assistant working on an exhibition for the Smithsonian, 1968. [54, 55] *Mathematica* exhibition, 1961. [56] Model of the IBM Pavilion, New York World Fair, 1964, designed by Charles Eames and Eero Saarinen. [57] Eames-designed furniture suspended from the ceiling for an exhibition in Singapore, 2013.

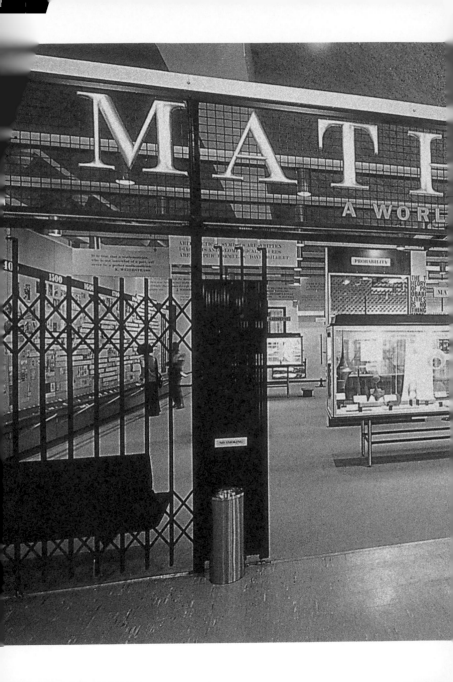

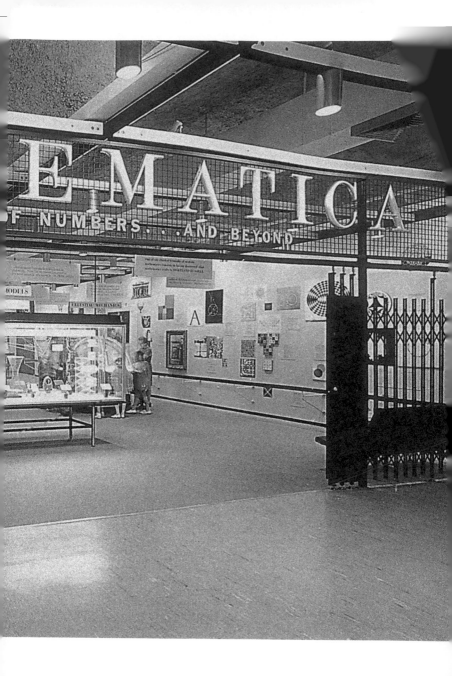

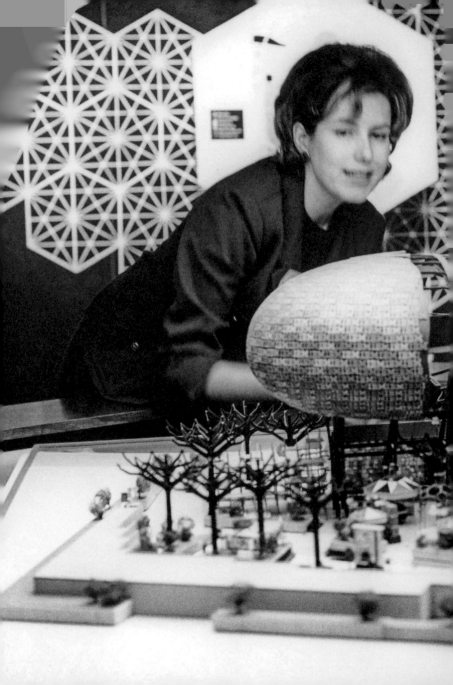

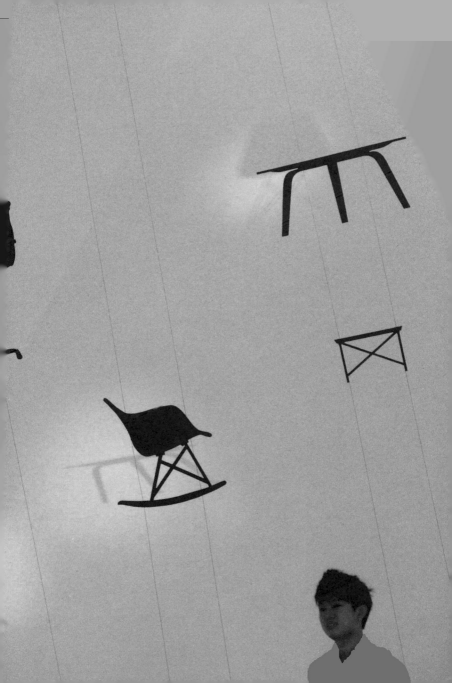

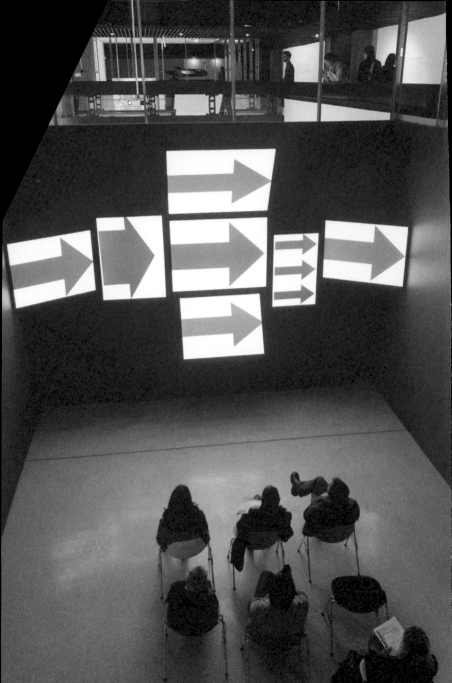

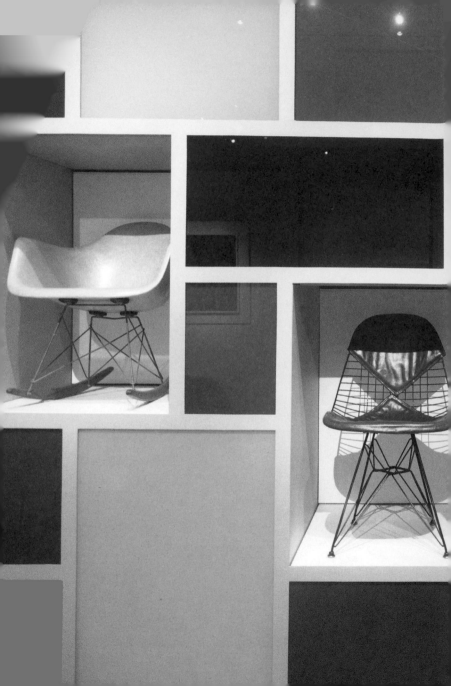

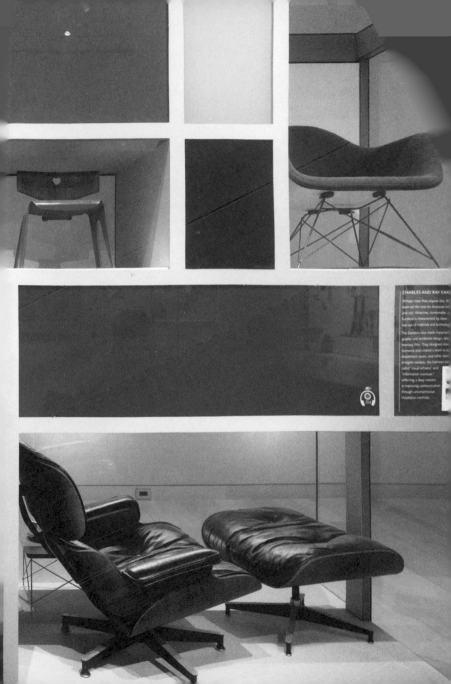

Perhaps most important, th
team set the tone for American in
and 50s. Attractive, comfortable, a
furniture is characterized by clean,
native use of materials and technolog

The Eameses also made importan
graphic and exhibition design, ph
memory film. They designed sho
elements and created a team to w
department stores, and other clien
in-gistic exhibits, the Eameses an
called "visual richness" and
"information overload,"
reflecting a deep interest
in improving communication
through unconventional
installation methods.

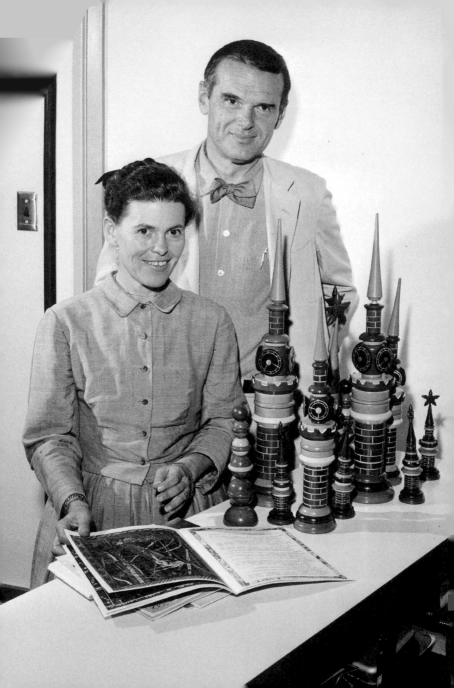

The publishers would like to thank the following sources for their kind permission to reproduce the pictures in this book.

Alamy /Alpha Historica 102–3/Andreas von Einsiedel 54–5/Arcaid Images 70, 71, 77/AztecBlue 107/Bailey-Cooper Photography 2 /Buy my stock picture 84–5/Jo Ingate 62–3/Marc Tielemans 59/Randy Duchaine 108¬–9/REUTERS 104–5/YA/BOT / 51. Bridgeman /©eames office 74, 75. Christie's Images Ltd 44, 45, 46, 50, 67. Corbis /Bettmann 52–3. © Eames Office, LLC. All rights reserved. 4–5, 7l, 7r, 13t, 13b, 15, 68, 72–3, 80t, 80b, 87, 88–9, 90t, 90b, 91t, 91b, 92–3. Jim Sugar Photography 41. Getty Images /Bettmann 82–3/David Cooper 58/Ken Lubas 23/Lawrence K. Ho 81/Tristan Fewings 86, 106/ University of Southern California 110/The Washington Post 98. Michael Freeman 40. Shutterstock /Andersphoto 64–5, 78–9/Karen Culp 47/ Nayeemislam25 61/Stephanie Braconnier 38–9. Tim Street-Porter /Beate Works 30–1, 32, 33, 34–5, 36¬–7, 42, 43. Vitra Design Museum 19, 56, 60, 66, 76, 96t, 96b, 97t, 97b /©eames office 10, 49, 57, 94–5, 99, 100-1. Vitra (International) AG 48.

The publishers would like to thank Eames Demetrios for his help with this book.

[58] *The World of Charles and Ray Eames* exhibition, the Barbican Art Gallery, London, 2015. [59] *The World of Charles and Ray Eames* exhibit, Oakland Museum of California, 2018. [60] Eames furniture at the Boston Museum of Fine Arts, 2017. [61] Ray and Charles Eames at their Russian exhibition, 1959.

MIX
Paper | Supporting
responsible forestry
FSC® C020056

First published in 2000.

This revised and updated edition published in 2023 by OH! Life
An imprint of Welbeck Non-Fiction Limited, part of Welbeck Publishing Group.
Based in London and Sydney.
www.welbeckpublishing.com

Text and Design © Welbeck Non-Fiction Limited 2000, 2023
Cover: Photograph of Eames DAL chair by Rama, Wikimedia Commons,
Cc-by-sa-2.0-fr

A CIP catalogue record for this book is available from the British Library.

ISBN 978-1-83861-115-6

Associate publisher: Lisa Dyer
Contributing writer: Rob Dimery
Design: www.gradedesign.com
Production controller: Felicity Awdry

Printed and bound in China

10 9 8 7 6 5 4 3 2 1